NAMAQUALAND *Garden of the Gods*

OTHER BOOKS BY FREEMAN PATTERSON

NAMAQUALAND

Garden of the Gods

FREEMAN PATTERSON

Key Porter Books

We would like to acknowledge the generous assistance of Nissan S.A. (Pty.) Ltd. in the publication of this book.

Key Porter Books
70 The Esplanade
Toronto, Canada M5E 1R2

Canadian Cataloguing in Publication Data

Patterson, Freeman, 1937—
 Namaqualand: garden of the gods

ISBN 0-919493-37-8

1. Wild flowers—Namaqualand (South Africa)
I. Title.
QK396.P37 1984 582.13′09687 C82-094601-X

Editor Susan Kiil
Design Antje Lingner
Map Sue Reynolds/M. J. Hale Graphics
Typesetting Cooper and Beatty, Limited
Colour separations Herzig Somerville Limited
Printing Herzig Somerville Limited
Binding The Bryant Press

Printed and bound in Canada

1 2 3 4 5 6 90 89 88 87 86 85 84

For Coenie and Colla Swart

Contents

In Namaqualand they say you weep only twice:

once when you arrive, and again when you depart.

Preface

Namaqualand is one of those rare places of haunting beauty that stirs the imagination and touches the soul. It is a land of bleak and desolate stretches of sand and rocks, of ancient plateaus dotted with klipkoppies and meadows. It is a land of prolonged drought where only the hardiest forms of life can survive.

Yet in most years, just when living things appear to have lost their foothold and it seems life has been sacrificed to the scorching sun, clouds gather, the sun disappears, and the rains fall. Spring soon arrives, and with it a profusion of flowers. Flowers beyond one's wildest dreams blanket the dunes and the meadows, making their way into the crevices of the rocky hills—and into the hearts of all who witness this fleeting miracle of life.

I will forever be drawn to this land—to its rare beauty and to the people who have become my friends. Through this book I hope they will share with me, and with others around the world, the exhilarating experience of viewing Namaqualand in bloom.

I am deeply grateful to Maurice Calvert-Evers, Garry Lovatt, and Chris Jackson for their initial interest in this project and for their continuing support through the writing of this book. I also want to express my appreciation to Susan Kiil, my editor, for her guidance, caring, and patience, and to Antje Lingner, Pat and Basil Katz, Louis Botha, Steve Botha, Barbara Lambert, and Michael Clugston for their generous assistance.

I wish to express special thanks to Coenie and Colla Swart, Louis and Dythea Marais and their family, Dirk and Irene Vermeulen and their family, and my friends in the Photographic Society of Southern Africa. Without their friendship and hospitality these photographs could not have been made and this book would not have been written. F.P.

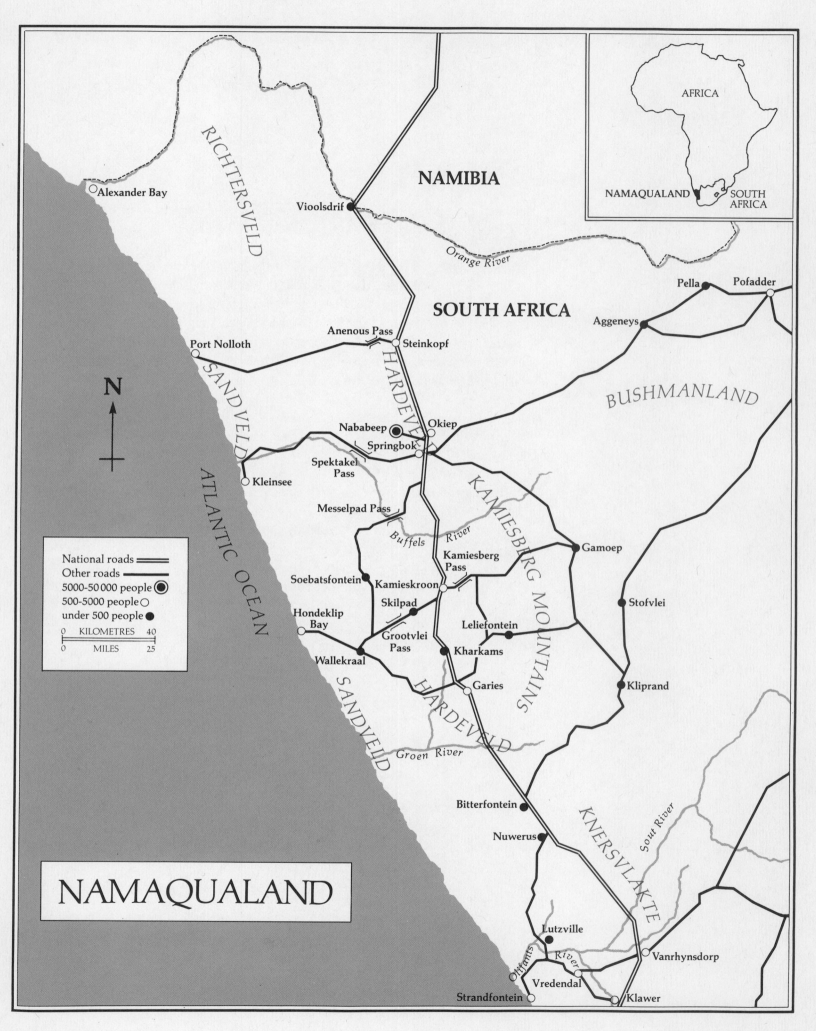

NAMAQUALAND

Introduction

The message from Namaqualand arrived at my home in late August: 'Heavy winter rains promise exceptional flowers.' To me it meant: 'Pack your bags!'

A few days later I was winging north from Cape Town along the Atlantic coast in a small eight-seater – circumventing the mountains of the wine country, dipping lower where the Olifants River empties into the sea, and then heading across the speckled desert past the little towns of Vanrhynsdorp, Nuwerus, and Bitterfontein.

Below lies Namaqualand – looking flat at first, from the air. To the east the brick-red soil is studded with low, blackish-green shrubs, each bush spaced equidistantly from its neighbours, guarding a circle of sand like a gannet defending its nest against the colony. This is empty, semi-arid country, scattered with dunes and traversed by an excellent highway.

The Kamiesberg mountains rise ahead to the right – the town of Garies, the mission at Leliefontein, and the tiny village of Kamieskroon snuggled at the foot of a pass. There are some green patches and washes of pink. It has rained here; the plants are growing and the flowers are opening. The pilot eyes me switching seats in the rear, trying to photograph from both sides of the plane at once. 'Flowers ahead on the right,' he huffs over the intercom, as he reads my mind and dips a wing. My head hits the ceiling as I scramble for a view. There they are – vast orange blankets folded around the bases of rocky hills, purple quilts tossed lazily over long, tenuous gullies, milk-white sheets rippling in the wind. I have seen the flowers of Namaqualand before, but not like this – not this spectacle of an entire landscape awash with colour.

The little plane drops below the highest peaks, curving its way through golden valleys toward Springbok, the hub of Namaqualand – 4000 people serving mining companies, small industries, and farmers. From the air I see orange daisies lining the streets and scattering up hillsides among white houses. People will be talking about the flowers. Some will be saying that the blossoms are better at Steinkopf or Kamieskroon, expressing the universal tendency to imagine that things are at least slightly better somewhere else. Nearly everybody will have different suggestions about where to go in order to see the very finest displays, but everyone will agree that Namaqualand in flower is one of the wonders of the world.

Down we come onto the dusty, red landing strip, the wind tossing yellow dassiegousblom and purple vygies as we taxi toward the tiny terminal. Two cars are waiting. The empty one is for me. I toss my luggage into the boot, lay my cameras beside me on the front seat, and drive away to photograph the wildflowers. Three hours later I have covered half a kilometre.

Spring comes to Namaqualand whenever it pleases. Winter rains from May through August signal its advent, but their ending does not herald its arrival. It comes when it comes – on a schedule and in a manner of its own choosing. It may peer around the corner of the year long enough for everyone to catch a glimpse of it, and then retreat. It may march in with fanfares, so swiftly and unexpectedly that nobody is ready for the parade.

Spring may leave almost as quickly as it arrives. Or, it may linger for weeks – lounging first on broad, sandy plains and then settling for a time on rocky hills. Or spring may slip away so quietly that you scarcely notice it's gone. Summer, with its blistering heat and parching winds, has taken its place.

Of all the seasons in Namaqualand, spring is the least predictable, the least dependable, and the most beautiful. It is a season for restoring one's soul, a time of hope and fresh beginnings.

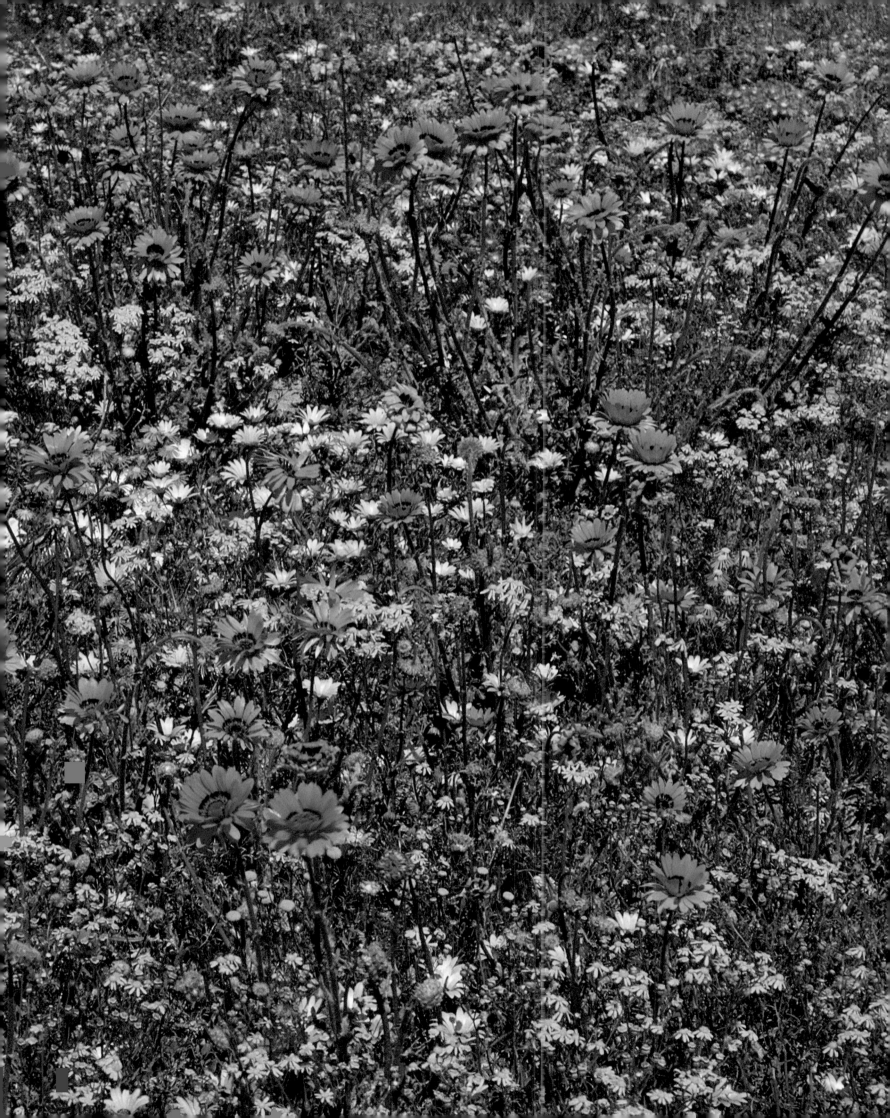

PRECEDING Because the best conditions for growth – adequate moisture with moderate heat – occur in Namaqualand mainly in the spring, the floral outburst is as brief as it is vivid. Everything seems to happen at once, producing an incredible concentration of bloom. An abandoned pasture or a fallow field becomes an ephemeral tapestry, the colour pattern a weave of thousands of individual blossoms.

BELOW AND OPPOSITE Every spring, conical, rocky hills (klipkoppies) become the rock gardens of Namaqualand. Giant boulders and outcroppings provide niches where soil and moisture collect and flowers bloom. These massive rocks, eroded, shaped, and smoothed by the weather of millions of years, are permanent backdrops for fleeting displays of colour. Here, between Steinkopf and the Anenous Pass, *Arctotis fastuosa* and other flowers have their brief moment on the stage.

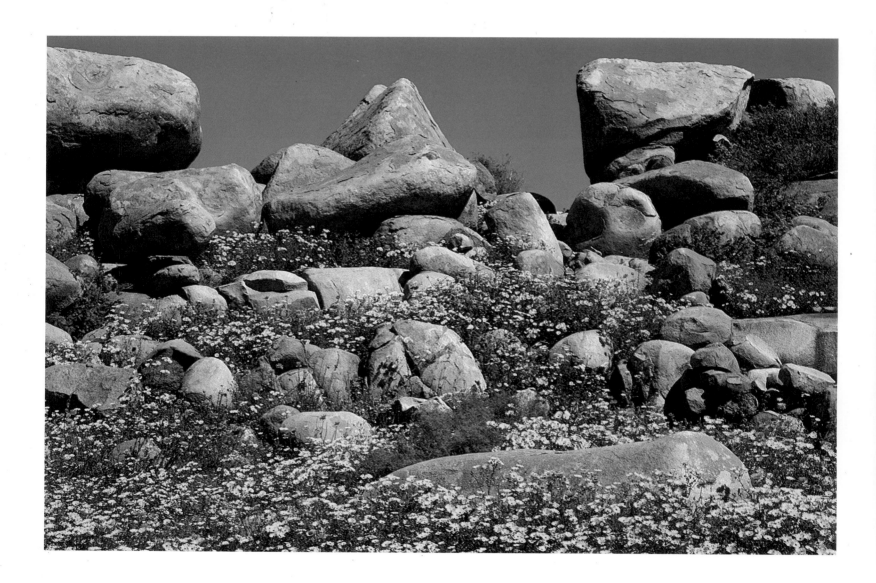

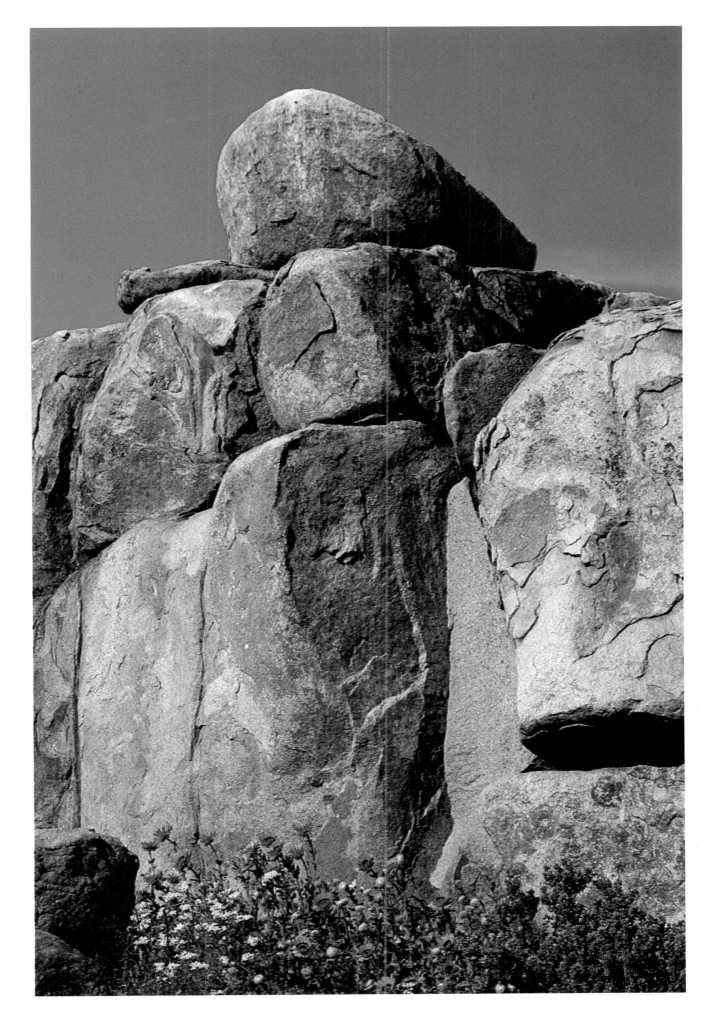

BELOW Introduced from Chile, *Amsinckia calycina* is an unpopular weed. Yet, the stalks of this much-maligned herb become a delicate tracery in warm, afternoon back lighting, rivalling in beauty of structure any of Namaqualand's native plants.

OPPOSITE The flowers blooming in a small section of unploughed field will provide more than enough seeds to turn the entire field, next year, into a sea of blossoms. Every undisturbed nook of farmland is a botanical storehouse filled with seeds that will replenish the areas man has borrowed.

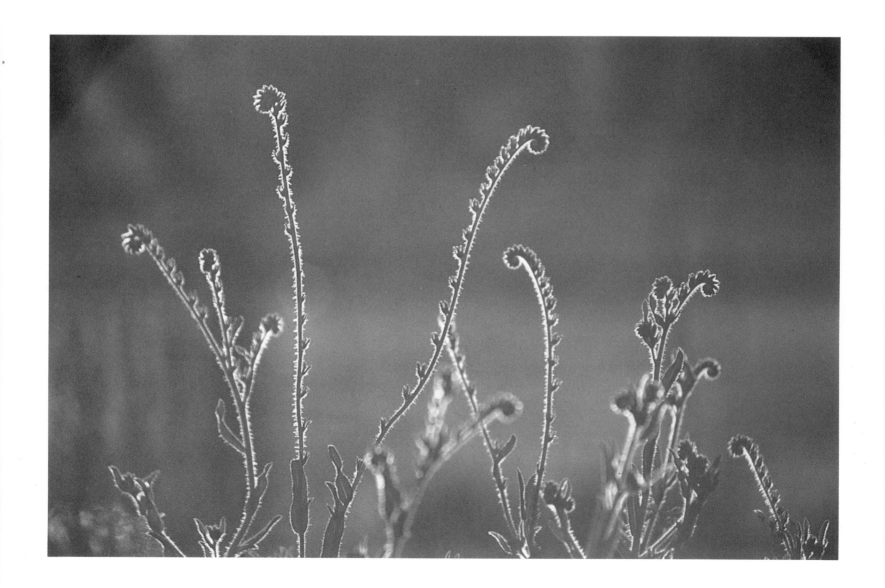

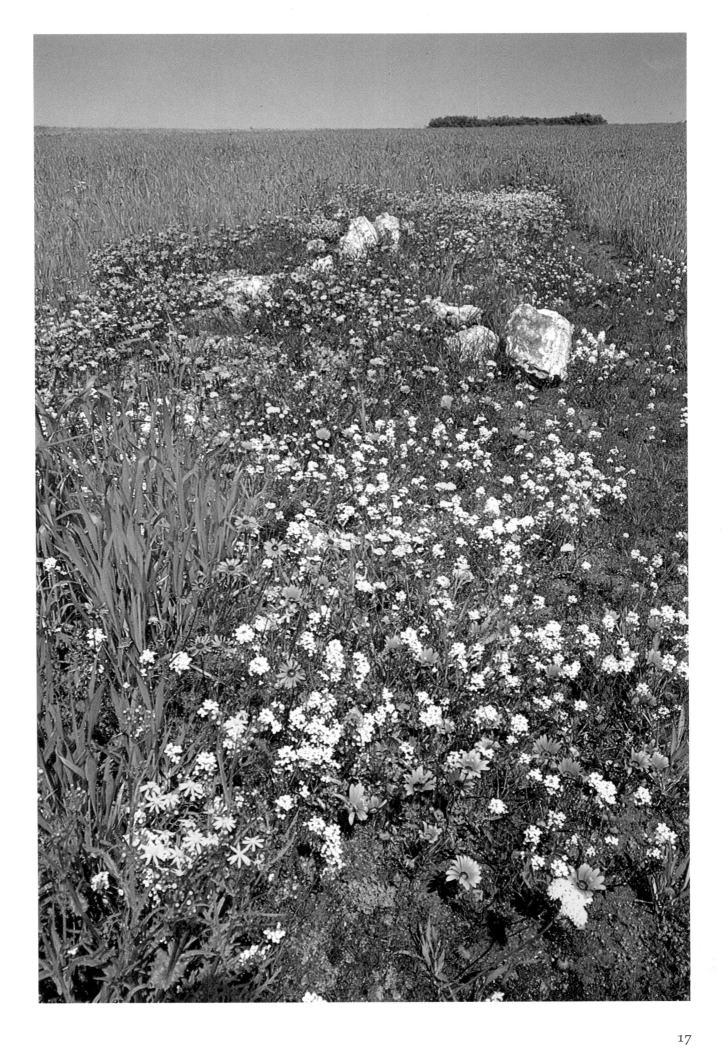

BELOW Wilderness often has a random appearance that masks the order in nature, but man's arrangements have more visible structures. At Pedroskloof, in the Kamiesberg mountains, large rocks seem to tumble down a hillside. Below them, people have cleared the stones away, ploughed, planted, and harvested, then left the soil alone for a while. Flowers have temporarily reclaimed the land, but the pattern of man's handiwork remains.

OPPOSITE Orange Namaqualand daisies, *Dimorphotheca sinuata*, spread across the land like a mid-day sunset, their glowing colour only arrested by the horizon. Known around the world as African daisies, the cultivated flowers rarely find conditions elsewhere as suitable as those that nature provides in Namaqualand, and nowhere else are the blooms as spectacular for their sheer abundance.

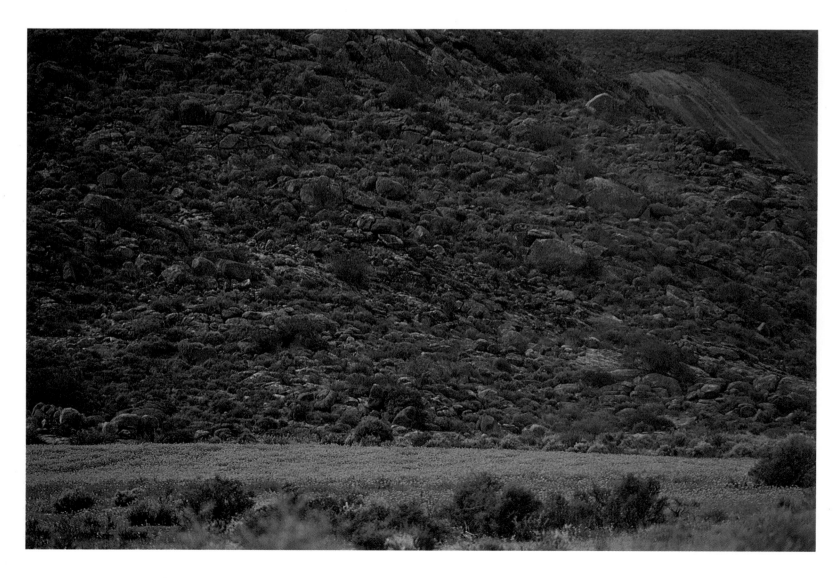

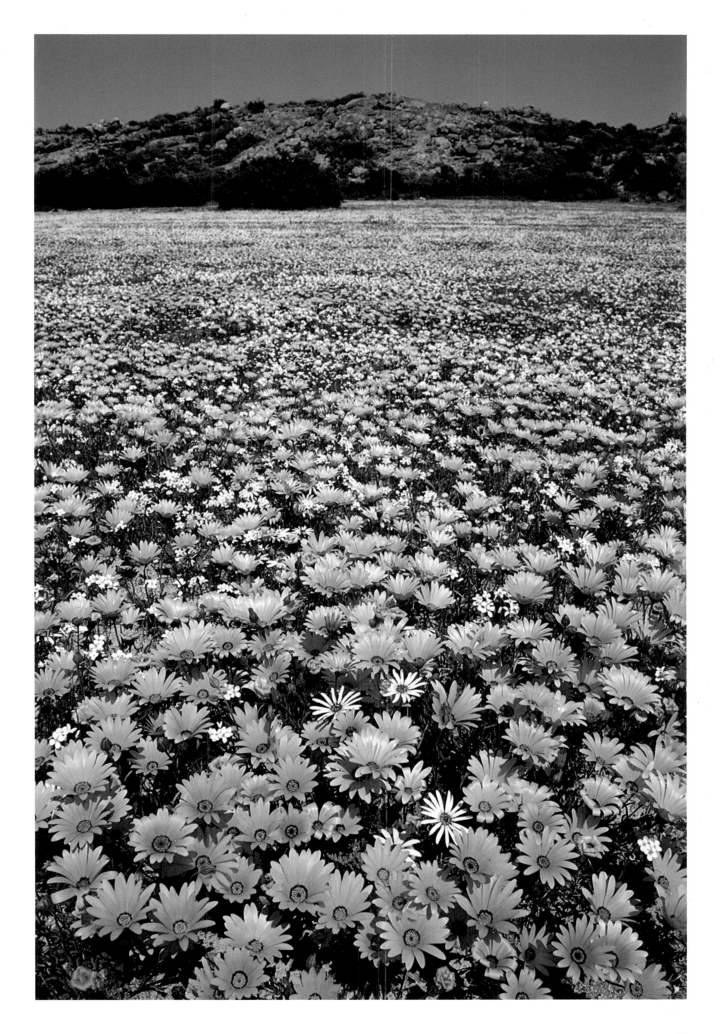

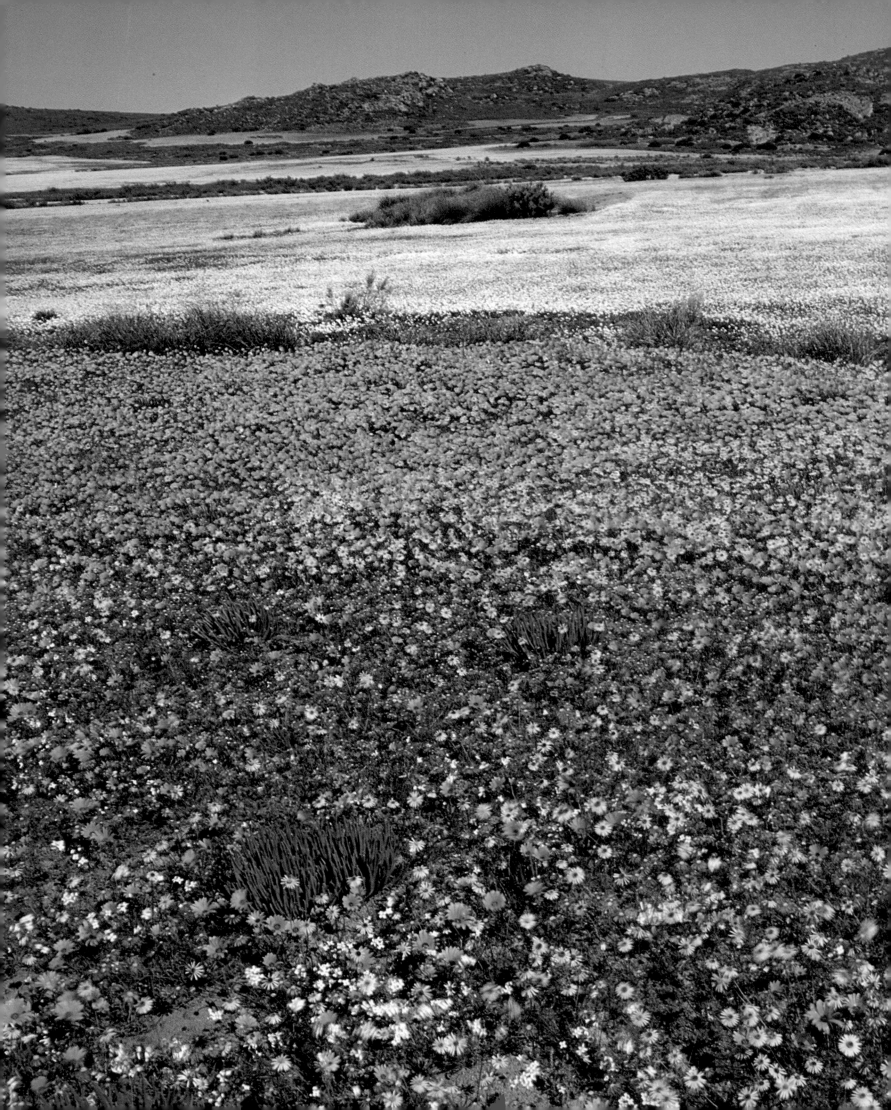

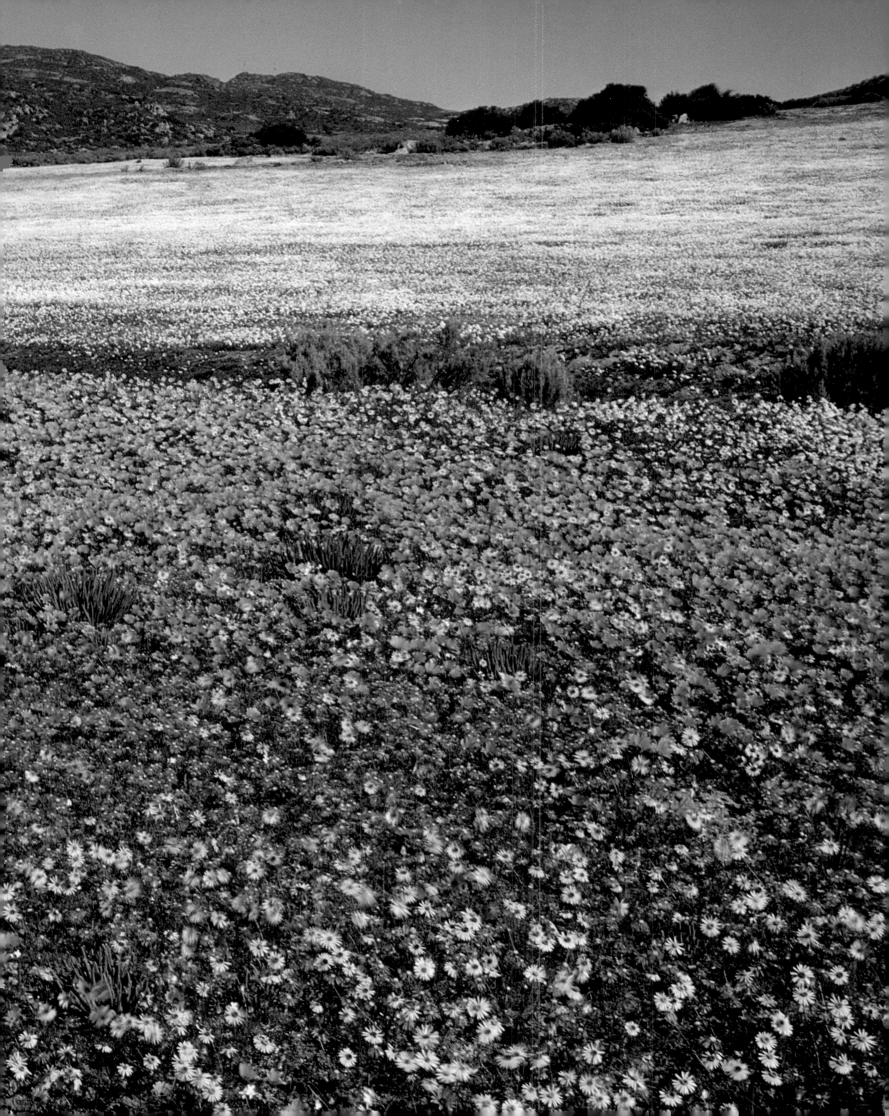

PRECEDING The grand spectacle of spring reaches the meadows above the Kamiesberg Pass a few days later than the fields at lower altitudes. Visitors who stop for a few days in one area to hike, explore, and watch spring unfold will find scenes like this and be able to return at different times of day to see how changing light alters the appearance and mood of the flowers.

BELOW When the sun's rays continue to beat down on a thirsty land, living things retreat into the soil and into themselves. Shrubs live by their roots. Perennial herbs survive as bulbs and corms, annuals as seeds. Insects and amphibians remain dormant in the soil. Migrating birds will delay their return, because food is unavailable. In this desert near Aggeneys, life is in waiting.

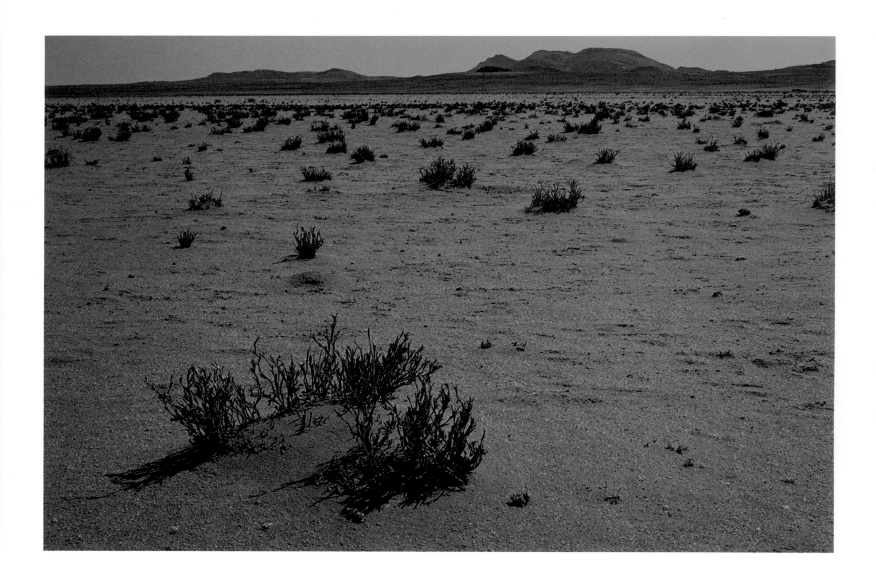

Many Namaqualand plants resist drought by storing moisture in underground corms or bulbs, and by adapting their leaves to minimize evaporation. The delicate *Morea tortilis* twists and curls its narrow leaves to reduce the amount of surface exposed to sun and drying winds. Other members of the genus have similar leaf variations, yet each species has adapted in its own unique fashion.

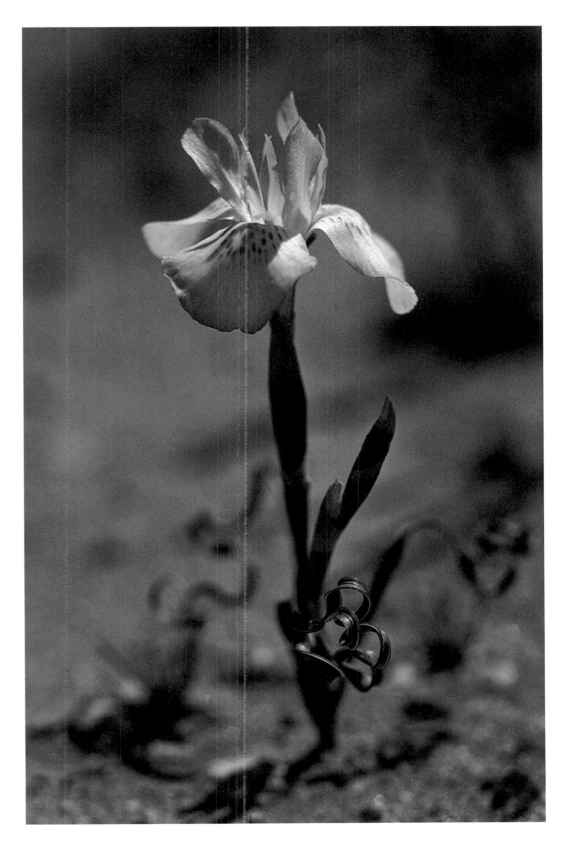

The sheer abundance of these flowers is evidence of their transience.
In climates where moisture is available for most of the year, the flowering season
spans many months, and species succeed species in a more leisurely manner.
The urgency to reproduce is lessened, and masses of bloom are not as common
as in Namaqualand.

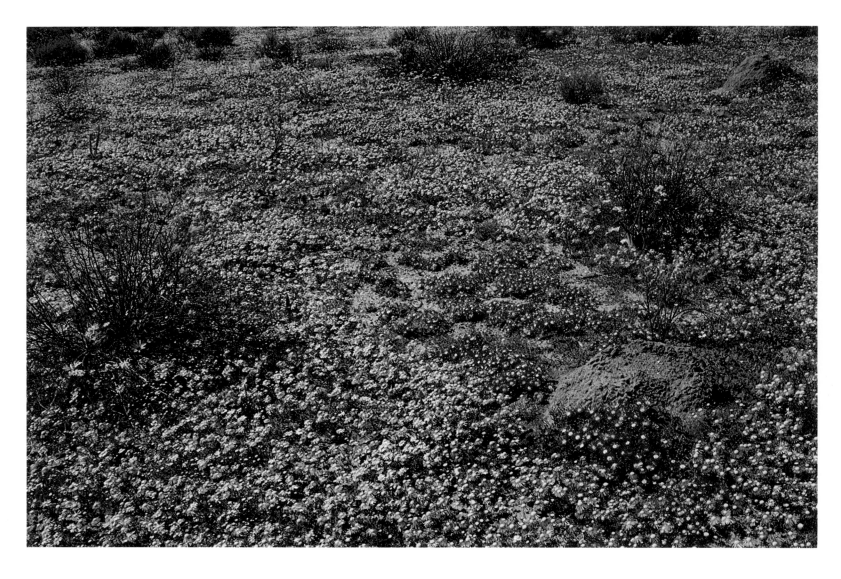

The tiny *Dorotheanthus bellidiformis* glistens in sandy soil. Like many members of the mesembryanthemum family, it will tolerate water as long as it doesn't have to stand in it. Blooming in a range of hues from white to pink to orange, this species has been widely hybridized and its many new colour variations may be found in gardens throughout southern Africa and around the world.

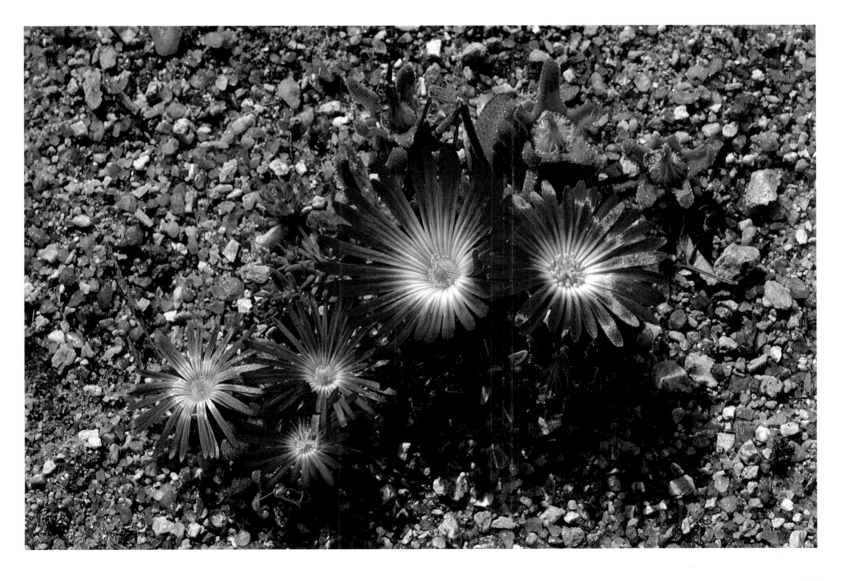

The shapes and colour markings of flowers lure insects, giving them precise instructions about where to find nectar – their reward for carrying pollen from flower to flower. Until the evolution of winged insects, the world was without flowers. Plants depended on water and wind to transport male cells to female cells, but where water was scarce, this method was inefficient and reproduction haphazard.

When nature tosses its coloured quilts over Namaqualand, it does not toss them everywhere at once, or even in some places at all. In springtime, it's possible to drive the entire length of the main highway through Namaqualand and see only a few flowers. Yet, a kilometre or two over the hills or along some lonely mountain road, the land will be blanketed with colour. The only people to see this display on the Kamiesberg plateau were occasional travellers who explored a trail that had no signs.

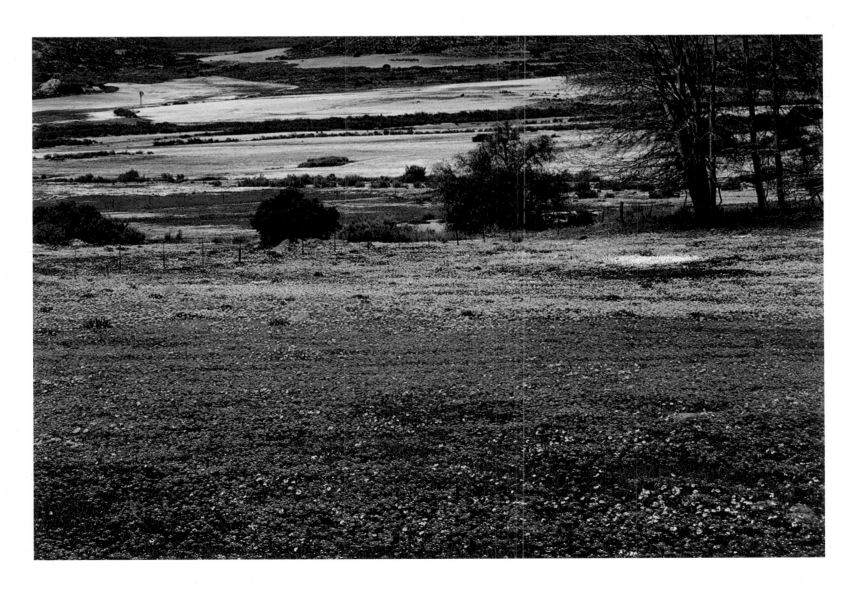

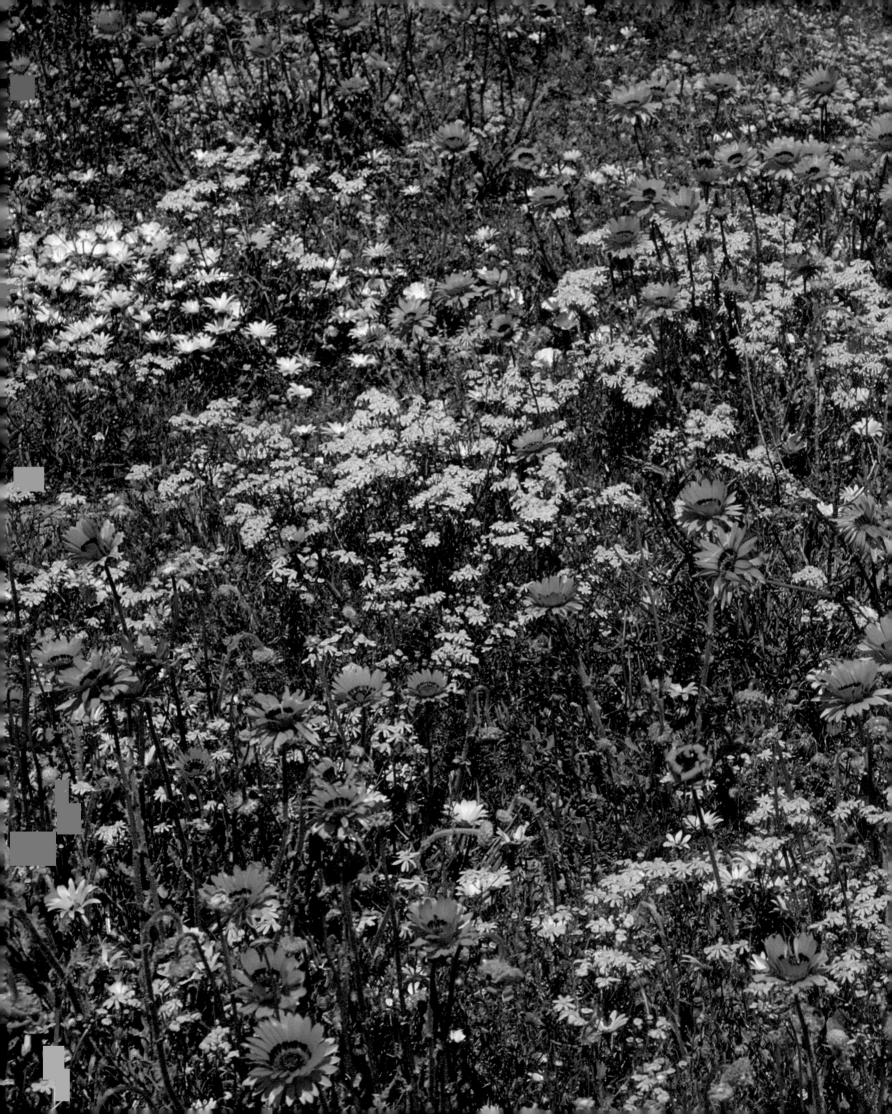

The face of Namaqualand

Implacable with age, Namaqualand sits in southern Africa facing the ocean and staring at the sun. Blistered, cracked, and wizened by years too numerous to count, its bronzed face reflects the harsh experience of an ancient settler who is long past being surprised by anything. But, when rain falls on its shrunken brow, streaming down weathered cracks and seeping into arid pores, the old mask dissolves into a thousand colours, and a new Namaqualand – vibrant with life and promise – lifts its countenance toward the sun.

The face of Namaqualand helps us understand the land and its message. When we gaze on the ancient countenance, we see beyond the narrow boundaries of human time and catch a glimpse of the eternal. But when the rugged visage is suddenly and briefly suffused with the hues of spring, we recognize in the flowers our own fleeting lives.

Namaqualand does not speak to us with words of shallow comfort. It tells the truth about the brevity of life, while offering flowers as symbols of hope and courage. We are able to believe that, like flowers buffeted, beaten, and scarred by external forces, we can still attain moments of excellence and great beauty. The flowers of Namaqualand suggest that the quality of time is more significant than the quantity.

At any moment, Namaqualand's face is a surface configuration of essentially permanent features, such as rocks and mountains, that are given shape by the wind, the rain, the heat, and the living things. These forces give expression to the permanent structure, the way a smile lights up a face. Just as we sense the inner lives of people by reading external signs, so we are able to discern the underlying character of Namaqualand by reading its fleeting expressions.

The *sandveld*, a long, narrow, coastal strip of red and white sand, stretches north all the way to the Orange River and south to the Olifants, which flows into the Atlantic beyond Namaqualand's southern boundary. The great waves of the ocean have brought white sand to the coast; winds have eroded inland plateaus and carried red soil to other parts of the sandveld. Though in many parts there is a distinct division between the white and the red sand, in other areas the wind has mixed and blended the colours.

The sandveld is dry, especially in the north. Port Nolloth receives only about 50 mm of rain a year, and may get much less. Air moving eastward across the ocean is chilled by the cold Benguela current, which flows up the Atlantic coast of southern Africa, causing water vapour in the air to condense into heavy mists. As these mists drift inland, they often blanket the veld, providing moisture and encouraging a sparse vegetation that helps to anchor the sand. As the ocean air is warmed by heat radiating from the land, the mist dissipates and, consequently, little rain falls.

The sandveld is a harsh environment for every form of life, with its winds, dryness, and sandy soil. There are large areas of dunes, some partly stabilized by low shrubs and grasses. Although shrubs and annual plants may bloom profusely in a good spring, a frigid Atlantic gale may close flowers on the sunniest

of days, so that a person searching for the scarlet sandvygie must be satisfied instead with the beauty of its folded petals.

Thirty to sixty kilometres from the ocean, the land rises into a rugged, mineral-rich escarpment of granite domes and pyramids and large klipkoppies (rocky hills) separated here and there by sandy plains. This is the *hardeveld*, a starkly beautiful region about 50 kilometres wide which stretches from just south of Steinkopf almost to Bitterfontein. The most striking feature of the hardeveld is the Kamiesberg – a mountain range of impressive peaks and valleys, and elevated plateaus and meadows studded with koppies and lichen-encrusted rocks. On the high plateaus, time seems to move forward and backward with equal ease. Awed by the magnificence of the surroundings, a visitor may be struck by the sense that successive millenia have altered the topography only a little. Here in the pre-Cambrian amphitheatres and rock gardens of the Kamiesberg, it's easy to imagine ancient gods tossing boulders in Herculean combat, and presenting to the victors wreaths of living sapphires and rubies.

Rain falls more abundantly in the hardeveld, especially in the Kamiesberg, than elsewhere in Namaqualand, and in winter and spring when the high meadows may receive up to 200 mm, green becomes a familiar hue. There are farms here, good farms, but agriculture is at best a difficult pursuit, suitable only for those who can cope with periodic drought and disappointment.

South of the hardeveld, outside the official boundary but still within the general region of Namaqualand, lies the *knersvlakte*. This undulating plain occupies an area between the Bokkeveld Mountains on the east and the sandveld on the west; it includes Bitterfontein on the north and Vanrhynsdorp on the south. Low shrubs dot the rolling, dusty-brown or brick-red hills, which are often heavily sprinkled with small, white, quartz pebbles. The impression is of an arid, sun-baked land, but when a heavy shower spatters off metal roofs and courses through the gutters in Vanrhynsdorp, the parched lips of the African soil drink up the moisture and the face of the knersvlakte changes into a carnival mask of dazzling cerise and purple, spotted here and there with yellow, orange, and red.

East of the mountains and klipkoppies of the hardeveld, the land falls away into the transitional hinterland of vast, monotonous plains, broken occasionally by blackish hills – the beginning of *Bushmanland*. This is a region of prolonged, merciless drought, especially in the north; of sand-driving, skin-parching wind, and searing heat in summer. Day after day, year after year, the sun may rise and set in a cloudless sky – sucking away all moisture and hope. Bushes become charred skeletons, seeds and bulbs lie dormant beneath the sand, insects retreat even deeper underground, and sheep and goats grow weak and die as the life-giving grasses are reduced to stubble. Farmers who have chosen to eke out an existence on this frequently barren veld, who have pitted their patience against the elements, might well wonder if they are gambling with God.

Then, it rains. After a decade has passed, after a young child has grown to adolescence, enough rain falls at the right time to produce a miracle on the veld – bushes come into leaf, plants grow and blossom, and grasses carpet the plain. When this hard, dry earth is suddenly transformed into a swirling galaxy of colour, the misty eyes of an old man or woman, whose patience is even greater than her years, reveal that God has granted the final, secret wish.

The only region as dry as Bushmanland is the *Richtersveld*, in the northwest part of Namaqualand. Gouged by the forces of water and wind, the deep, eroded chasms of this forbidding moonscape are stalked by drought. Formidable rocky peaks blister in the fierce summer heat that has been known to reach almost 50°C, and stony plains blind the eyes with reflected light.

Some areas of the Richtersveld have no plants at all, so inhospitable is the rocky surface. Other areas seem to have none, though sometimes what looks like a pebble may really be a stone plant (Lithops), a tiny succulent that will burst into bloom with a lick of moisture in spring. Yet there are some parts of the Richtersveld that can support woody shrubs and many succulents. Here, when the spring rains come, there may be a colourful display of annual flowers. But most of the time the earth is stark and barren, and the plants retreat from the hostile forces of nature.

In this lonely, haunted land live half-mens, the strangest plant in all Namaqualand – a tall, spine-covered succulent that resembles a short, slightly-stooped, wooden telephone pole with a rosette of leaves at the top. The Nama people compared the plant to a human spirit. Silhouetted against an evening sky, it reminds one of an elderly gentleman whose head is nodding in conversation or drooping with fatigue; but in the bright African moonlight it resembles a ghost wandering aimlessly on the veld.

The indigenous people of Namaqualand – the Bushmen who were nomadic hunters and collectors, and Nama Hottentots, nomadic herders – lived in such close harmony with nature that they did not distinguish between its physical and spiritual dimensions. By reading hoof prints in the sand, Bushmen hunters setting off in search of food could choose which gemsbok to kill long before they encountered the herd, but when the quarry was finally within the reach of arrows or spears – perhaps after an all-day chase – they would release their weapons only when they had a clear shot at their target, lest they injure the young or female members of the herd. Then, perhaps 50 or 100 kilometres away from their families, the hunters would turn and unerringly head home – and long before they arrived, the women and children would somehow know they were coming with meat, and welcome them with song. The ensuing celebration was in honour of life – the success of the hunters and the animal that had traded its life for theirs.

These early people lived by the seasons, and their eagerness for rain after long dry periods was not, in the first instance, out of concern for themselves. They knew where to dig deeply in the sand for their own water supply, but if the animals fled or died of thirst, starvation would be their fate as well. Thus, the promise of rain after a protracted drought was cause for rejoicing, surpassed only by the rainfall itself.

Though the Hottentots kept cattle and therefore had a more stable food supply than the Bushmen did, they were equally dependent on water. Thus, rain was a symbol of life for the aboriginal people just as it was for the white explorers who first crossed the Olifants River in the 1680's in search of copper, and for the trekkers who ranged north into Namaqualand with their cattle and sheep.

For the early trekkers and settlers the connection between life's material and spiritual aspects was probably greater than it is for Namaqualand's present inhabitants. They lived so close to the land and were so acutely affected by the weather that physical deprivation and temporary abundance were regarded as chastisements and rewards directly bestowed by the Almighty. The frontier people learned the meaning of resourcefulness and the importance of gratitude – and many managed to fashion livelihoods on nature's grim conditions.

Today the prolonged drought, the coming of rain, the fleeting spring bloom, and the massive rocks continue to be powerful symbols. They represent life and death, and the human concern for a balance between the transitory aspects of life and a sense of permanence. In this age-old land of granite koppies and drifting sand, the face of the earth and the needs of the people are constantly changing, yet forever remaining the same.

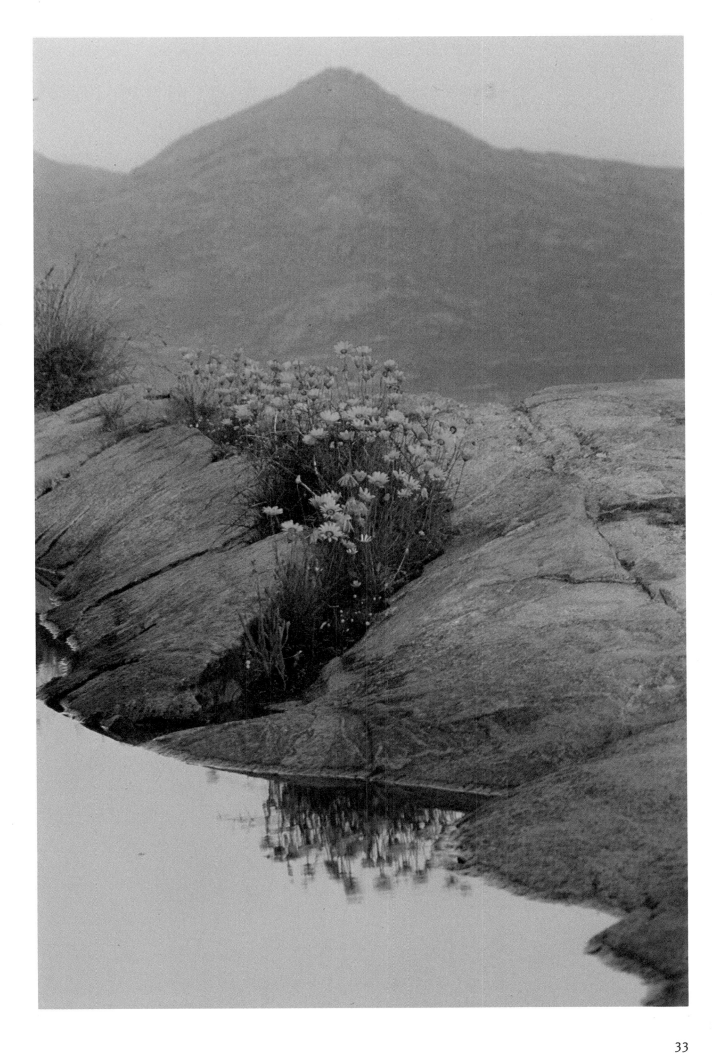

PRECEDING On a remote koppie east of Kharkams, an unknown gardener –
perhaps the wind – planted a clump of glowing *Ursinia calenduliflora*
beside a reflecting pool. I discovered them in the hush of a gentle sunset and,
after photographing them, I put my camera down and sat at the edge
of the pool until darkness fell.

BELOW The forces of wind, water, and heat, help convert rock to soil.
Early in this process lichens begin to colonize the rock surface. As the process
continues over thousands of years, organic material and moisture collect in
crevices that develop in the rock, and higher forms of plant life move in. Their
roots exert more pressure on the rocks, their leaves add to the growing
accumulation of organic debris, and the transition proceeds.

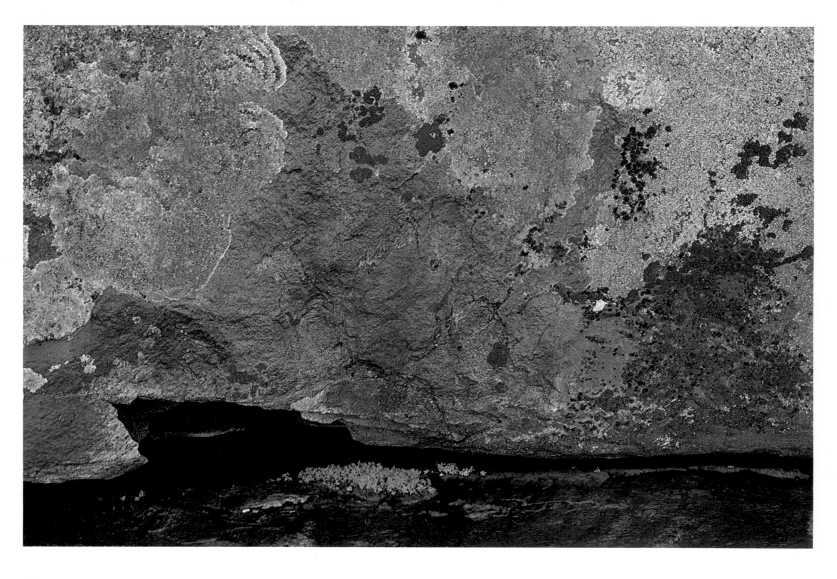

A *Babiana* blooms in a split in a boulder, which provides shade for its corm and roots. Once in blossom this species does not close its petals until the flowers wither. The best time to photograph the plant is on an overcast day or early in the morning when the rock shades the bloom, as the rich bluish-purple hue is more beautiful in indirect light than in bright sunshine.

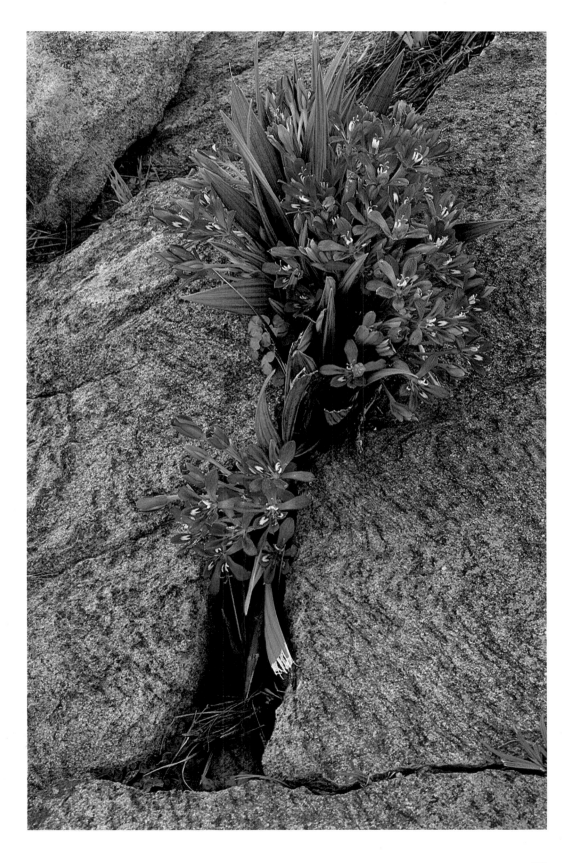

Hemimeris montana can usually be found at the base of large rocks or banks that provide shade and moisture. Like the *Babiana* on the preceding page, its glowing colour photographs best when the sun is not shining directly on it. Photographers who visit Namaqualand in springtime should rise early to take advantage of the lighting conditions, especially if they are making close-up pictures of a variety of wildflowers.

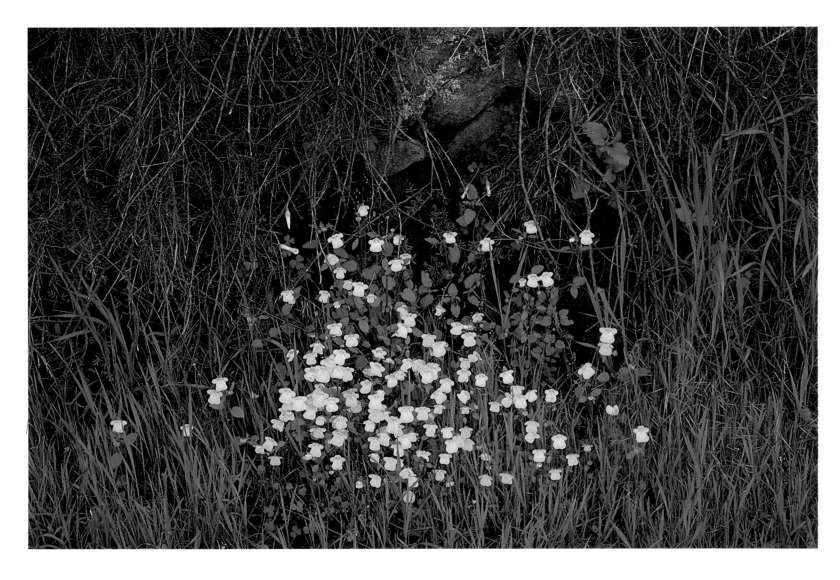

Soft back lighting gently outlines a *Lachenalia* blossom late in the afternoon. This lily often nestles among rocks, singly or in groups, or marches in long lines down the crevices in a koppie.

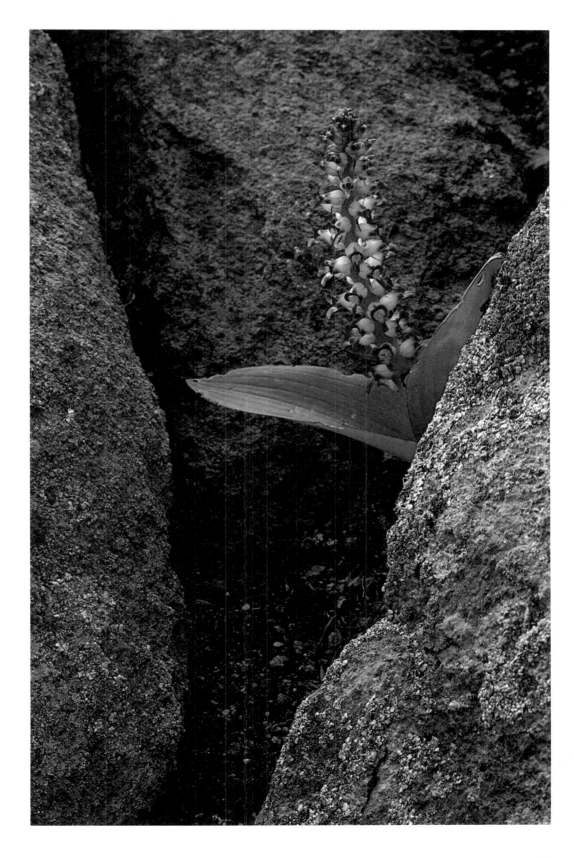

When it rains, tiny pools of water collect in depressions on the koppies of Namaqualand. If successive showers replenish the pools for a few weeks, or if cloudy days reduce evaporation, you can find *Limosella capensis,* a tiny water lily, floating on the surface. Of all Namaqualand's flowers, none illustrates more clearly the life-giving power of rain.

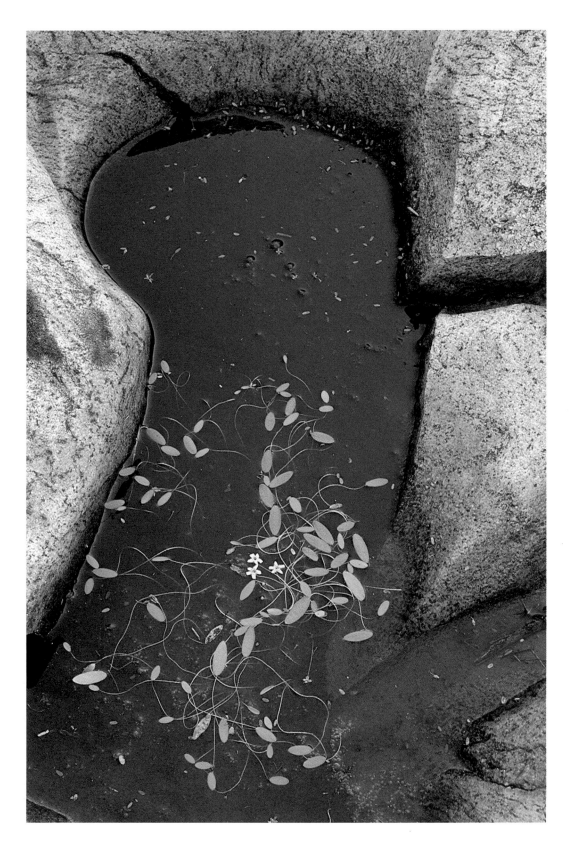

BELOW Sculptured by nature over eons of time, a wall of granite provides a setting for *Silene* that no artist could match. The rocks and the flowers evoke the two great themes of the Namaqua landscape – stability and transience.

OVERLEAF Mesembryanthemums herald spring at the top of Grootvlei Pass. At lower altitudes the flowers open a few days earlier, their colour advancing steadily up the hillsides as the season progresses. But spring is an unreliable visitor here. When cold winds off the Atlantic hurtle through the valleys, the flowers close for protection against the blast – and wait. Then, as the winds abate and warmth returns, the blossoms open.

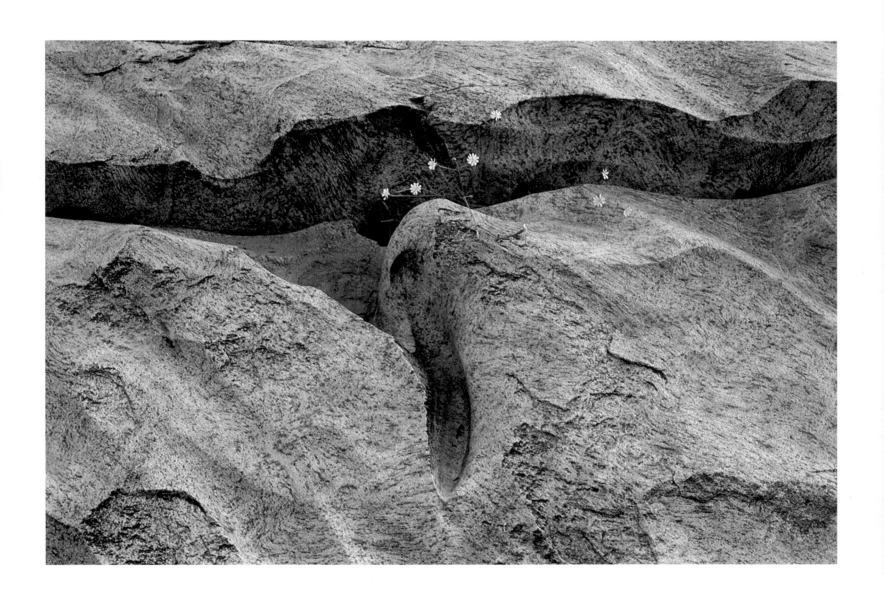

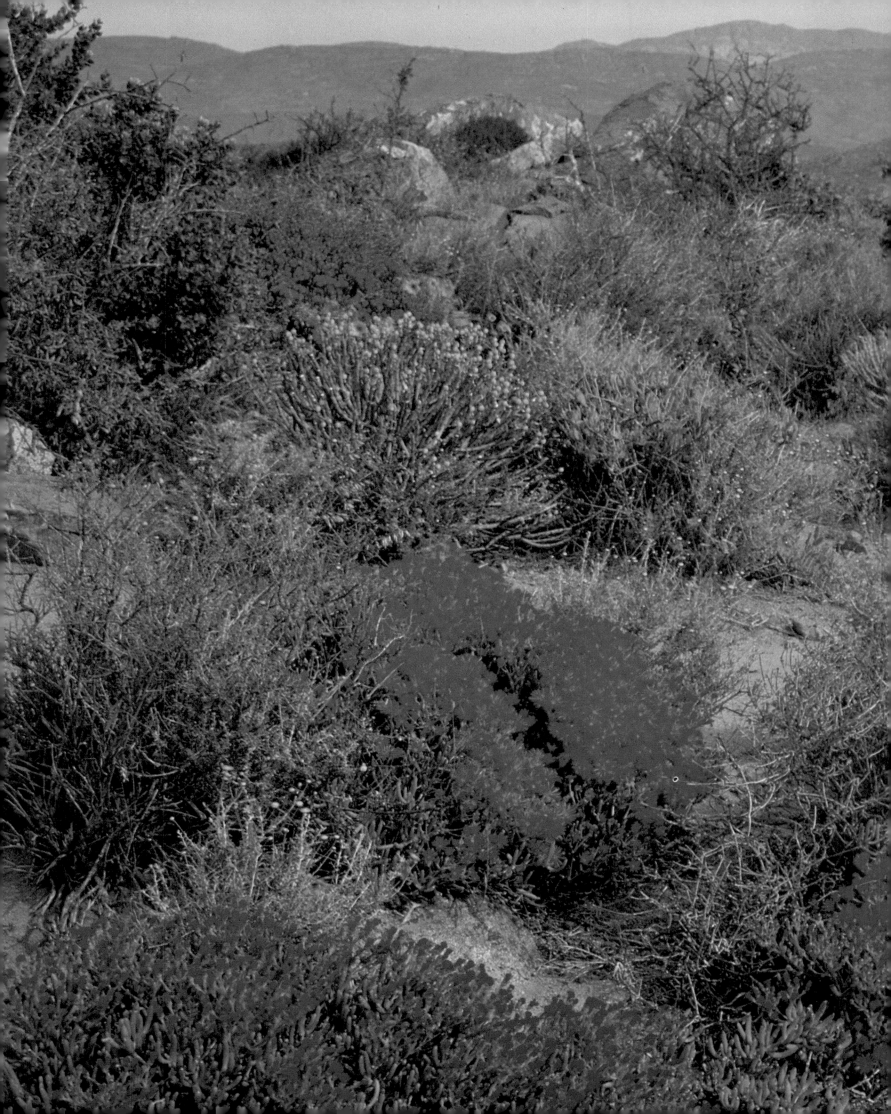

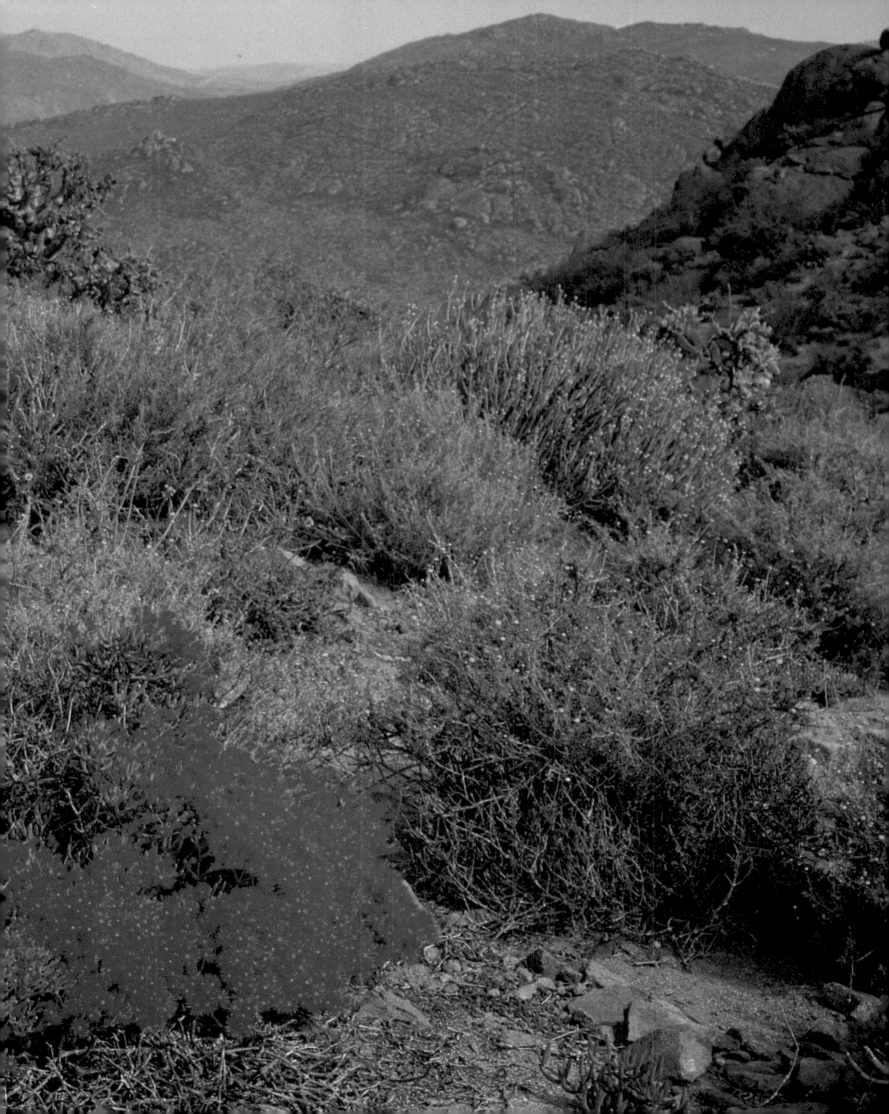

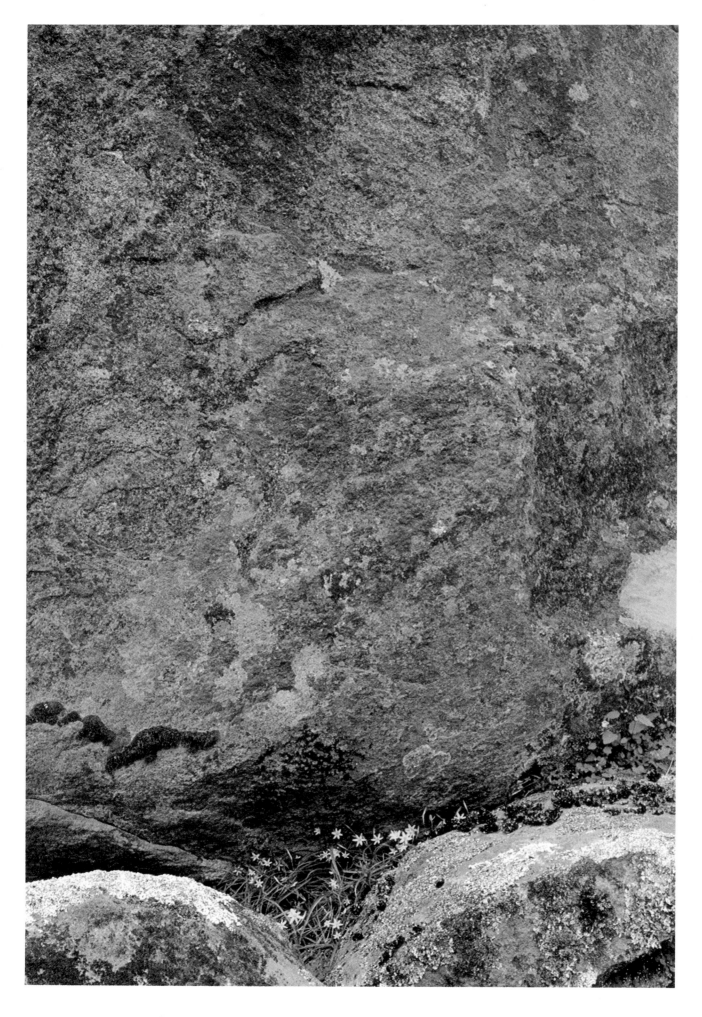

The great rocks of Namaqualand shelter plants from searing heat and
numbing cold. They are the natural home for oxalis, lilies, iris,
and myriad other species. Here flowers live, find food, and reproduce,
paralleling the life cycles of mammals, reptiles, insects, and other creatures.

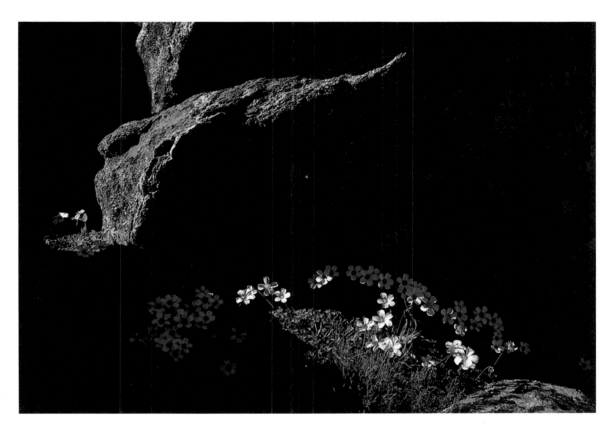

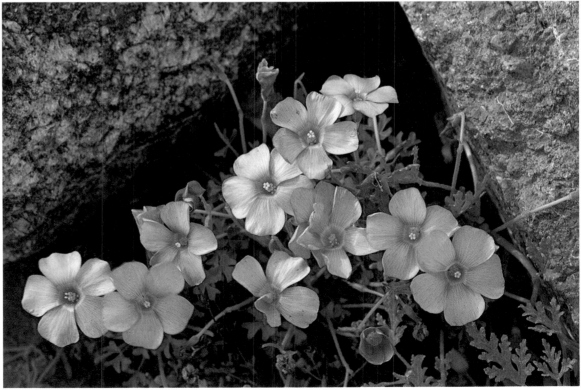

Nowhere are the designs of the land more apparent than on the koppies.
Lines in the rock face direct one's gaze to a point of emphasis. A *Pelargonium
echinatum* becomes an exclamation mark, rivetting attention to a single spot.
If the eye wanders, it is led back repeatedly – until the mind begins to contemplate
the natural forces that shape the land and give it life.

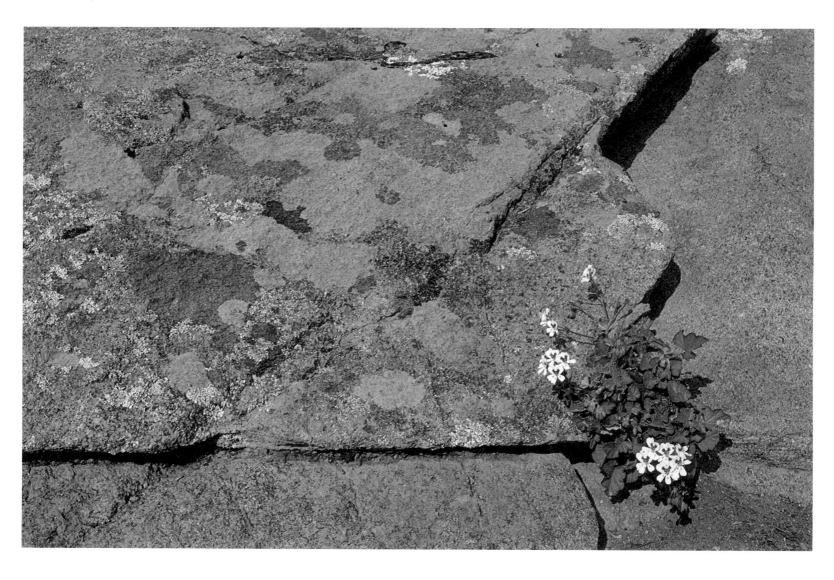

A clump of *Lapeirousia* arrests the eye and focuses the attention, like a jewel set in stone. Such a discovery is the reward of the hiker, the photographer, and everyone else who slows down in order to see the world in its fullest sense.

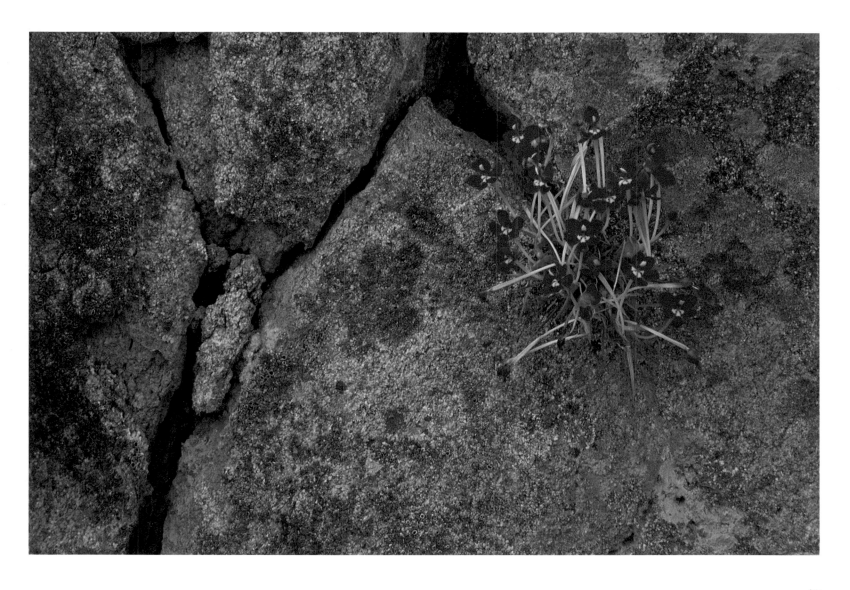

Often a small niche houses a community of plants, each species using the resources of the habitat and, in turn, adding to them. Near the Anenous Pass, *Gorteria, Wahlenbergia,* and *Leyserra* share a nook in a rock, becoming a natural floral arrangement when they all burst into bloom at the same time.

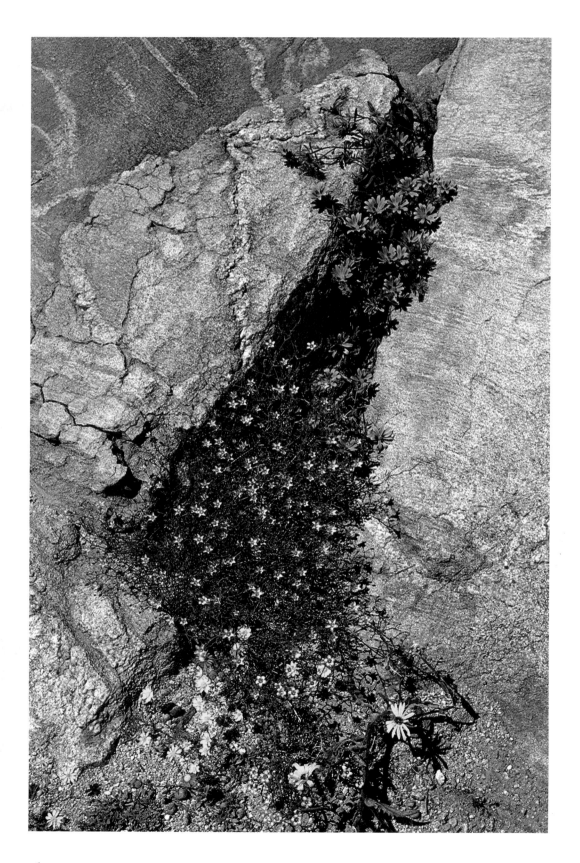

BELOW The two basic visual elements – colour and form – stand out strikingly in the Namaqua landscape. The hues of the land change with the season, the time of day, and the quality of light, reminding native and visitor alike of the fleeting nature of living things. But, the landforms remain, being altered so imperceptibly that they have the aura of eternity. Namaqualand touches the human spirit profoundly because it confronts us at a fundamental level, through its immutability in a world of change.

OVERLEAF Few rock gardens are more lovely and more useful than those planted by nature itself. Insects will visit in search of nectar and, in return, pollinate the *Ursinia, Lapeirousia,* and *Lachenalia.* Birds will come for the insects. In these and countless other ways this wild garden will contribute to the food chain and other processes on which all nature depends, including man.

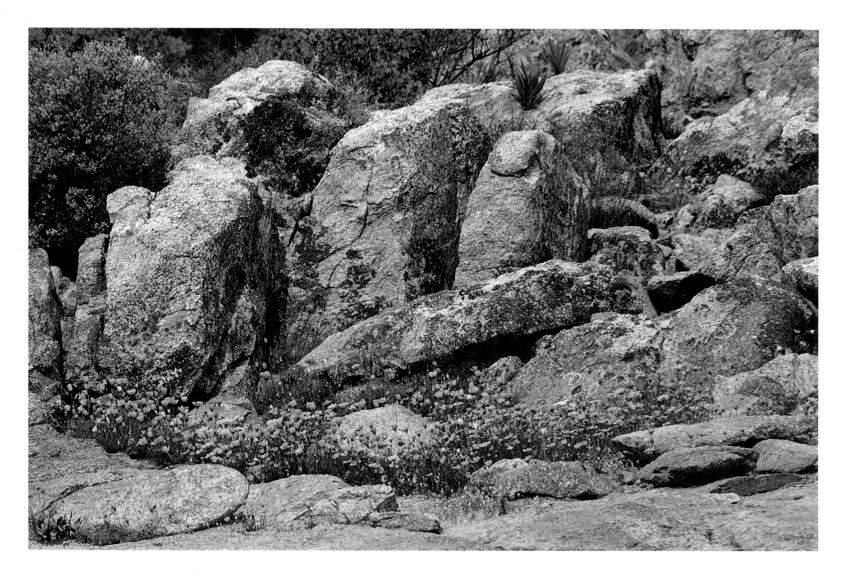

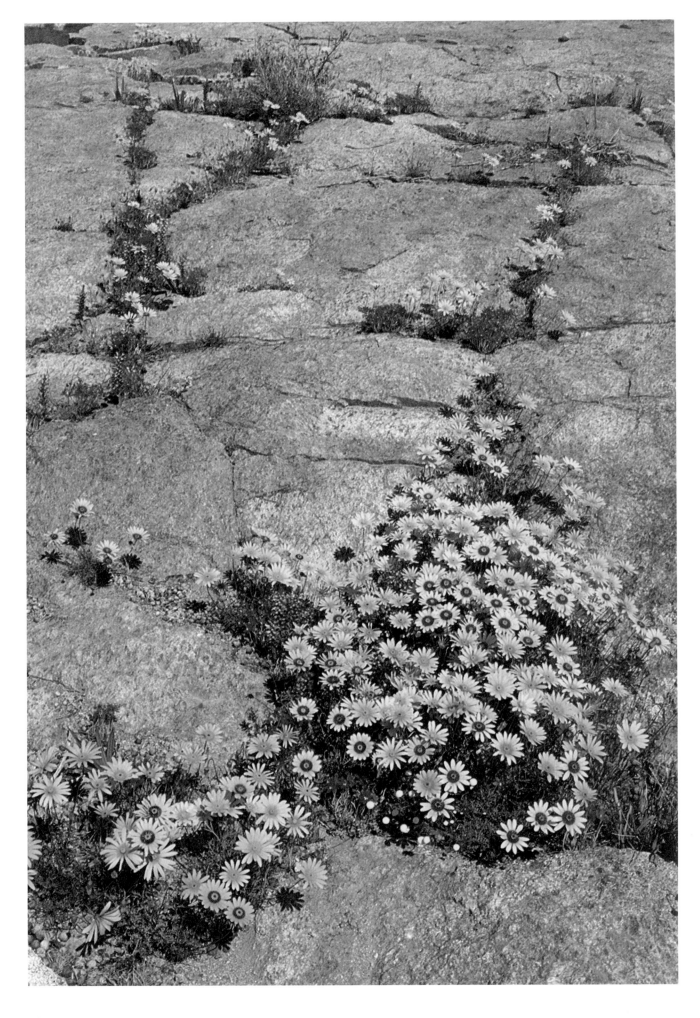

Spring comes to Namaqualand

As Earth circles the sun, revolving on its axis, and tilting first one way and then the other, summer in Namaqualand changes into autumn, and autumn, in its turn, gives way to winter. Yet, the passing of one season and the advent of its successor cannot be clocked precisely. Even from one region of Namaqualand to another, the seasons may disagree about the timing of their arrivals and departures. Spring is often the most indecisive season of all. For the people of Namaqualand, spring means flowers, and they may start blooming abundantly as early as the end of July, or as late as mid-September. In some years, they bloom in profusion all over Namaqualand; in other years, they carpet widely-separated parts of the landscape; and sometimes, they are sparse everywhere. However, most years, spring does bring flowers somewhere.

Sown by the wind, seeds will lie indefinitely in dry, dusty fields or lodge in dirt-filled crevices in the rocks. Shrubs cast away their leaves or, sipping sparingly from interior wells to stay alive, become wizened in the sun. Bulbs sleep. But, when winter brings rain, there is a stirring, a movement without sound to the human ear. If enough rain falls the pace of activity quickens. But water, by itself, is not sufficient to complete the promise of spring. There must also be warmth. Where moisture and heat are in proper balance, the seeds will germinate, the bulbs will sprout, the leaf buds of shrubs will unfold, and a patina of green will portend the coming of flowers.

Because spring is unpredictable, visitors should come with an open mind – ready to enjoy all aspects of the landscape. You will undoubtedly see some flowers, but if you witness the floral spectacle of a good year, consider it a special bonus. If you can time your arrival for early in the season and can spend several days or a few weeks in Namaqualand, you may want to commence your journey in the north, or perhaps in the northeast at Aggeneys, and slowly wend your way southward as spring progresses, although there is no guarantee that spring will follow your itinerary. This was my September journey one year.

Aggeneys, September 6. As we left Pofadder for Aggeneys, the veld glowed pink, red, and gold in the sunrise. We stopped while the air was still cool and explored some low dunes, discovering the tracery of insects and blowing grasses on the sand. Later in the morning, we investigated the ruins of a long-abandoned home on the veld, and noted how nature was reclaiming the site. Although it was extremely dry, the desert rose was blooming and one bush had even established itself inside the crumbling walls. But except for the desert rose and a few hardy shrubs, there were no other flowers blooming in this part of Bushmanland.

By early afternoon the heat was intense. On very flat, sandy stretches, we could see waves of heat radiating from the earth, and were startled by a mirage of a glassy sea. Soon after that, a scorching wind came up, and by the time we reached Aggeneys we felt parched all over.

Nothing was growing in Aggeneys, except new housing and lawns – a consequence of mining development. The town was neat and clean, but after the trip

across the lonely veld, it seemed strangely out of place, like an earth station on the moon. A lady at the post office told us that we would see flowers tomorrow as we drove toward Springbok – it had rained to the southwest.

Springbok, September 8. Shortly after we left Aggeneys, we stopped to walk across the flat, sandy, red veld that was dotted here and there with the skeletons of shrubs and interrupted in the distance by low, pyramid-like mountains. Some years, this lonely stretch is blanketed with flowers, but yesterday it was the sheer emptiness of it that attracted us.

Just after we resumed our journey, we encountered our first flowers – an occasional white vygie and, in a shallow depression of cracked mud, a few brilliant yellow gazanias. Then, within a kilometre, the earth was transformed. Yellow gazanias stretched across the red sand as far as our eyes could see – a startling contrast to the inverted blue bowl of the sky. But, this year, there was none of the famous Bushmanland daisies here.

As Bushmanland began to blend into the hardeveld, the variety of species increased, and we became so absorbed by patches of silvery-yellow duikerwortelblom, huge clumps of varkiesknol, and fields of golden dassiegousblom that the sun was setting by the time we entered Springbok.

This morning we walked around Springbok. A clump of yellow daisies was blooming by the petrol pumps at Jowell's Garage, and across the street the little koppie had become a wildflower garden. At the Masonic Hotel, I overheard a woman remarking that she'd never seen more flowers in Springbok, but perhaps she doesn't live here. I wondered if she had visited the cemetery – the daisies were blooming among the artificial flowers and, outside the fence, the earth was an orange carpet. This afternoon we made short trips to Okiep and Nababeep to see places where copper is mined and smelted. On the way we saw beautiful displays of Namaqualand daisies.

Port Nolloth, September 10. Yesterday morning, we set out from Springbok for Port Nolloth, and stopped at a koppie west of Steinkopf. Streams of yellow hongerblom and scarlet-orange bittergousblom cascaded over massive granite boulders. At the base of the koppie, the earth sloped away through a glittering mosaic that extended far into the veld. The temperature and breeze were comfortable, so we decided to spend the entire day walking among and enjoying the flowers.

We were glad we did, because today as we descended the Anenous Pass and crossed the sandveld to Port Nolloth we saw only occasional flowers. But the drive was interesting, nonetheless. We visualized earlier times when prospectors searched for diamonds and when mules hauled railway trucks loaded with copper ore from Springbok, Nababeep, and Okiep through the pass and across the sandveld to the coast – and we wondered how many mules it took to pull one loaded truck and what prevented the trucks from going too fast on the downhill sections. Later, in Port Nolloth, a man at a garage told us about brake blocks that were used behind the wheels of the trucks and also related stories of passenger coaches that plunged off sharp bends in the track. No wonder passengers travelled for free!

We stopped to photograph small dunes of red sand forming in the lee of a lone hill and then, nearer the sea, the white sand rolling into larger dunes partly covered with low shrubs.

It is good to feel the cool, refreshing wind off the water, to smell the salt, and to hear the surf. Even in late afternoon, the light is hard and brilliant – from a

distance all the gleaming white shops of the town seem to have been etched on the land.

Kamieskroon, September 14. We drove back from Port Nolloth, through Springbok, and then on to Kamieskroon on September 11. Although we intended to spend only a couple of days in this area, there are so many side-roads to explore that we will probably spend a week or more here. Some trails lead down into the sandveld, another into the Kamiesberg and beyond, and others just seem to wander all over the place – through the best displays of flowers we have seen so far. However, the weather has changed – it is no longer sunny and warm.

Yesterday some friends and I built a cooking fire on the sandy bottom of a dry streambed in Killian's Pass on the road to Hondeklip Bay. We had a "braai" of grilled mutton, chicken, pork, and vegetables. A very chilly wind was blowing through the pass, and there wasn't much pleasure in sitting out in the open, even though we all wore warm sweaters or anoraks. The bushes on the banks of the streambed broke the force of the wind, so it was fairly comfortable there, especially when the sun broke through the heavy clouds. But, we certainly misjudged the weather! Many of the flowering shrubs and all of the double Namaqualand daisies on either side of the streambed were closed. However, after a splendid meal, we went as far as Wallekraal to walk among the old, deserted buildings before doubling back to Kamieskroon.

Today the wind was much worse – frigid and violent! All night long I heard it slamming doors, shaking windows, and clattering metal containers along the tile floor outside my bedroom. Even though I went to bed with four woollen blankets over me, I got up during the night to put on a sweater and a jacket. This morning when I turned on the hot water, the room filled with steam. But, I suppose the weather could be worse. If this were a scorching east wind, there wouldn't be a wildflower left by tomorrow. And, I have an opportunity today to study my wildflower guidebook, write some letters, and chat with the woman from Cape Town who knows so much about insects.

Kamieskroon, September 19. We've been up in the Kamiesberg every day since the wind died down on the evening of the 15th. The weather has been wonderfully spring-like and the flowers superb.

Early this morning, we hiked to a waterfall some distance from the village. There was very little water flowing in the stream and soon there will be even less, but evidence of water was everywhere. Over an area of several hectares, the rocks have been gouged, eroded, and polished for millions of years by the swollen stream that flows over them during the rainy season.

The eroded rocks provide innumerable niches, ledges, and islands where wildflowers grow – in some places, a single plant; in others, luxuriant bloom. The contrast between the rocks and flowers is striking; the rocks are so hard and permanent, the flowers so delicate and fleeting.

Kharkams, September 20. Today we said farewell to Kamieskroon and after driving the 20 kilometres to Kharkams, meandered along narrow dirt trails in the hills and valleys to the east. There were flowers everywhere, but on one large klipkoppie the variety and abundance of blossoms was astounding, so we stopped there for the rest of the day. There were long parallel lines of banded ursinias in the crevices, pocket-like gardens of button daisies, lachenalias, and lapeirousias, and a host of less common species. Here and there a clump of flowers was perfectly reflected in the pools of water that filled depressions in the

rock. From the top of the koppie we could see bands of clouds streaming along the rugged peaks of the Kamiesberg and could look down into deep, flower-spangled valleys.

Garies, September 21. This morning we followed the main highway from Kharkams to Garies, then turned east along the Groen River, expecting to go to Leliefontein and back, but we didn't get very far. The plants along the roadside were in full bloom, so we stopped our Datsun "bakkie" several times to walk on the veld. On the reddest soil, white manuleas were mixed casually with orange Namaqualand daisies in colour patterns we hadn't seen before. The river was full and brown from yesterday's heavy shower, and flowed swiftly across a drift a few kilometres from Garies. Early in the afternoon we turned back toward town, and spent the rest of the day on the hillsides around Garies, where vegetation is quite different from that along the river. The vygies were at their very best – dazzling our eyes with their shimmering purples and reds.

Bitterfontein, September 25. To our surprise, there were not many flowers blooming along the highway between Garies and Bitterfontein – no grand spectacles of the sort we have seen recently on the hardeveld. But, we have learned that the veld can be deceptive, especially the knersvlakte, so we stopped occasionally and went for short hikes. We were rewarded every time, not by masses of flowers but by individual plants we hadn't seen before or by lovely combinations of familiar flowers.

It seems strange to hear the shunting of railway cars again. Bitterfontein, small though it is, has an industrial air about it because of the coming and going of lorries, the railway, and the constant loading and unloading. These things remind us that our visit to Namaqualand is nearly over, something we have tried to ignore. We are already outside the official boundary of Namaqualand, but the flowers are paying no attention to the line on the map.

Tomorrow, after breakfast, we will drive to Vanrhynsdorp, then the next day east into the Bokkeveld Mountains, south through the Sederberg, and then return to the main highway around sunset for the final push to Cape Town.

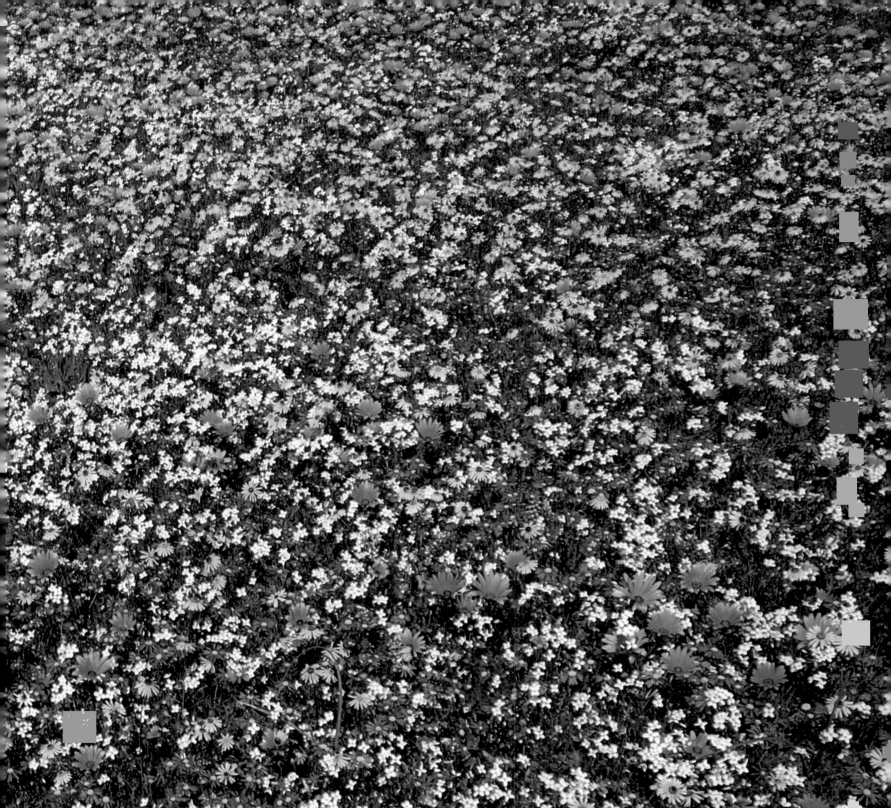

PRECEDING An hour earlier, these flowers were closed. When the cool wind abated and the clouds dissipated over the Kamiesberg, the temperature rose quickly, and the blossoms opened.

BELOW Wild tulips, *Homeria miniata*, do not herald spring, but mark its sure arrival. Arrayed in salmon-pink or white, these members of the iris family dance across dry soil in sandy places or congregate by the thousands in damp, well-drained earth. Here and there, their yellow-costumed cousins, *Homeria schlechteri*, mingle with them.

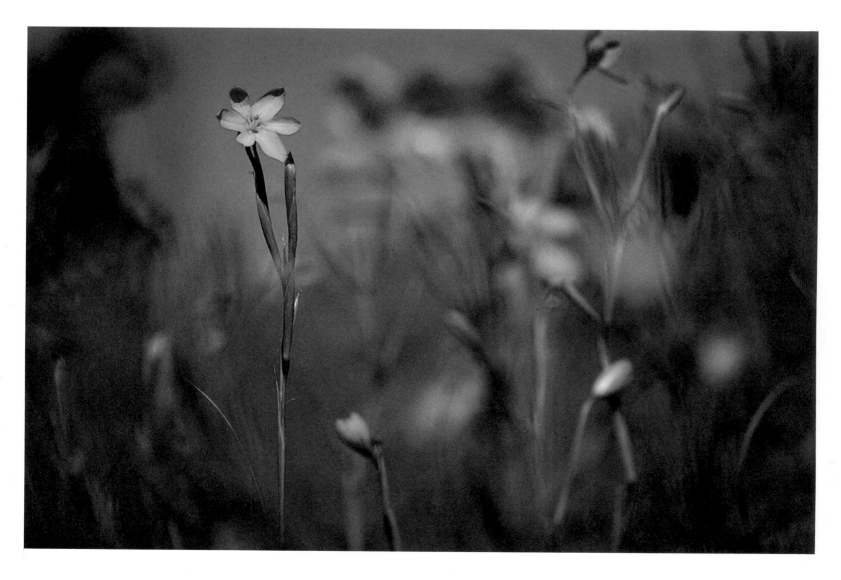

Gladiolus scullyi, another member of the iris family, is one of the ancestors of the modern garden hybrids and just as lovely in its own way. There's something special about coming across this flower blooming on a koppie or standing alone in an open patch of meadow between rocks. One wants to pause longer than usual to examine its splendid form and hues.

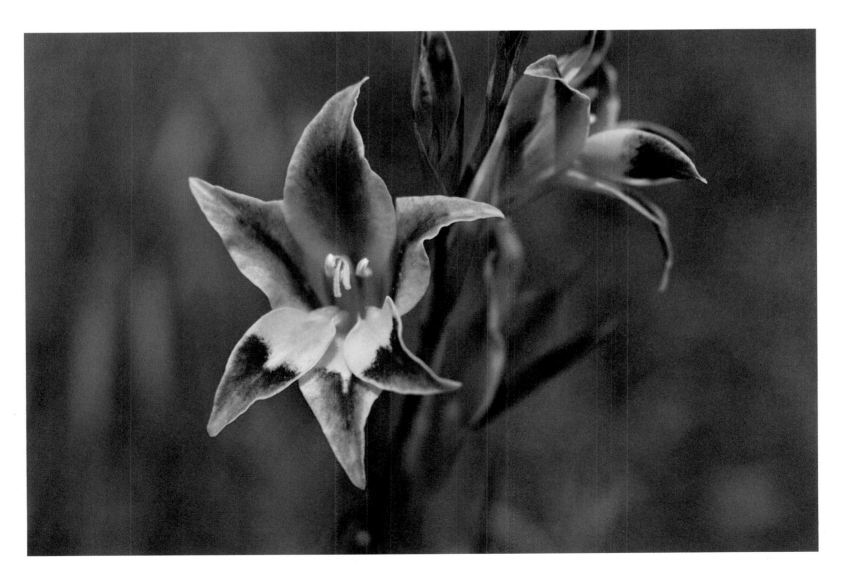

A farmer leaves his trail on a carpet of pale blue *Felecia*. Yet, like footprints
on the seashore, it soon will disappear. When the flowers fade and die,
and the earth is brown and dry again, these tracks will be nearly indistinguishable
from the surrounding soil. The flowers and the man will become memories
together.

Hottentot's cabbage is a lily that can be used as food. The young, unopened tips of the flower stocks may be steamed or added to stews. One of the many edible wild plants of Namaqualand, its past popularity as a food source can be attributed in part to its wide distribution. This is a huge specimen.

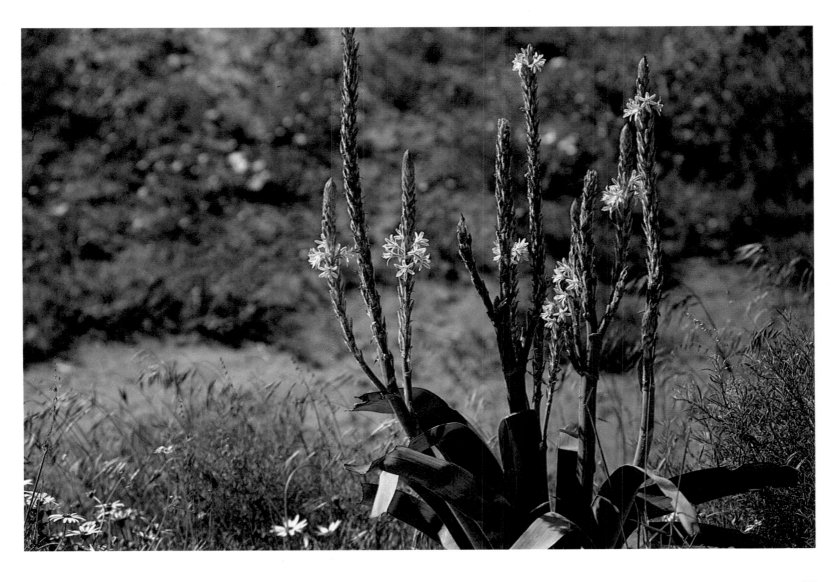

On the road to Hondeklip Bay, a red *Dorotheanthus*, or sandvygie, closes its petals tightly against a frigid Atlantic wind.

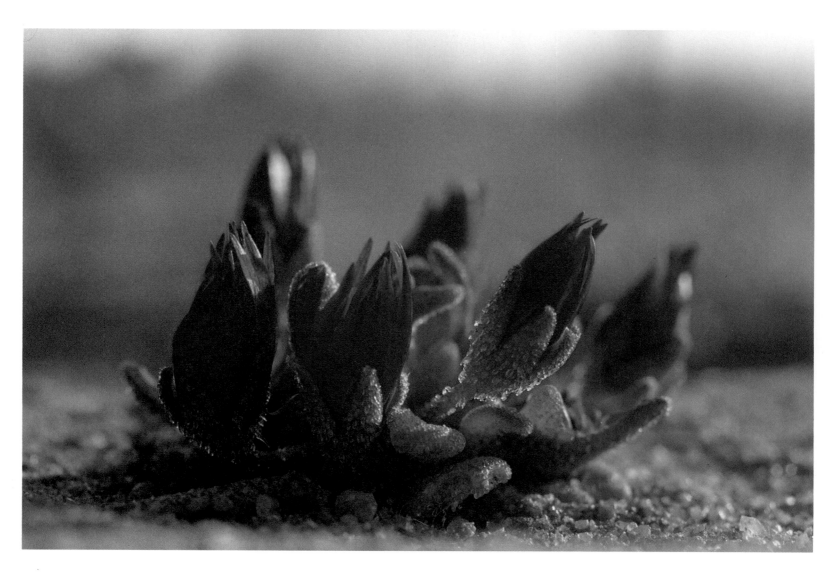

BELOW *Hyobanche sanguinea* is a parasite that lives on the roots of nearby plants. While the species is also distributed widely throughout the southern part of Cape Province and Namibia, even a regular hiker on the veld may discover the flower only occasionally, because it is not abundant and bushes may mask it from view.

OVERLEAF There are certain days – in Namaqualand and the world over – that define spring. The colours on the palette could belong to no other season, and hues are fresh and buoyant. On these special days a sense of luxuriant abandon emanates from the land and fills the human spirit with delight.

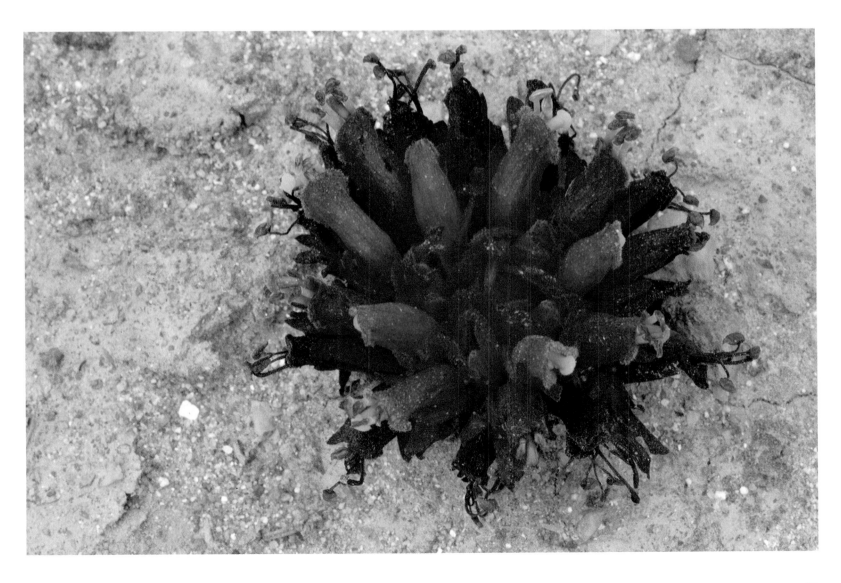

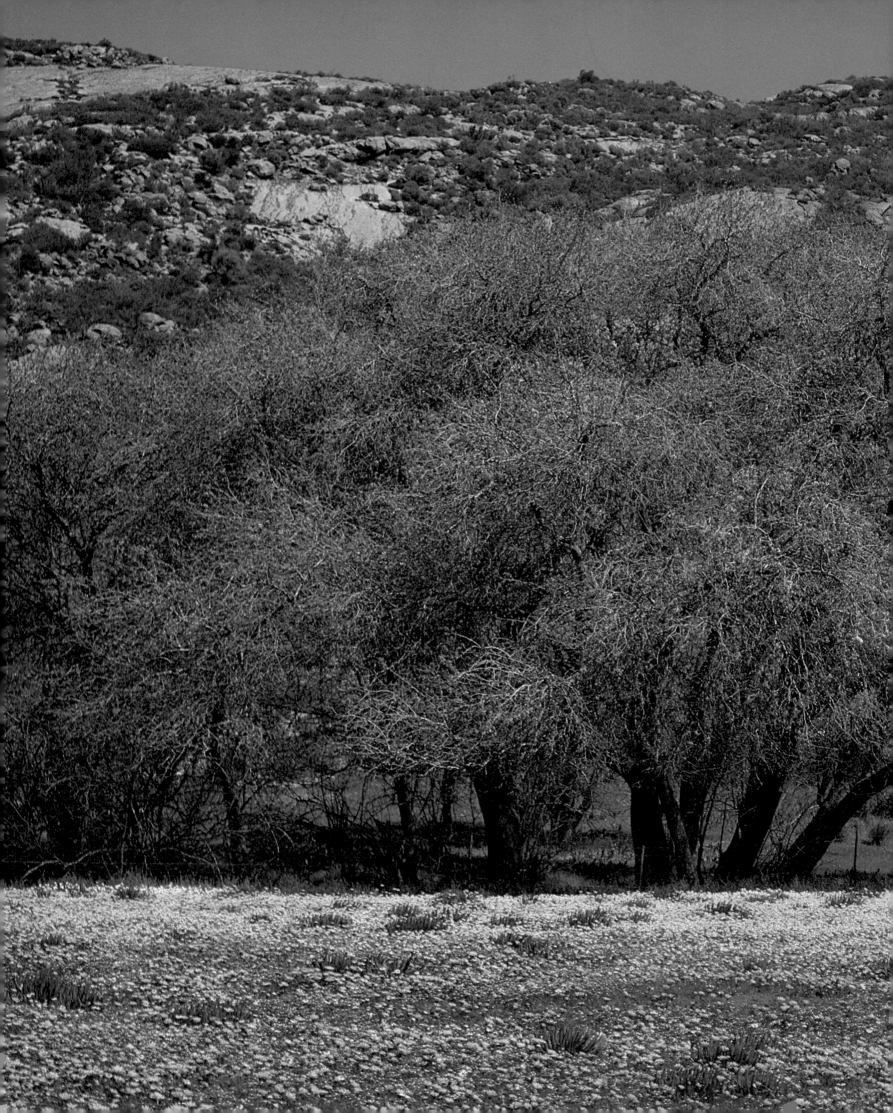

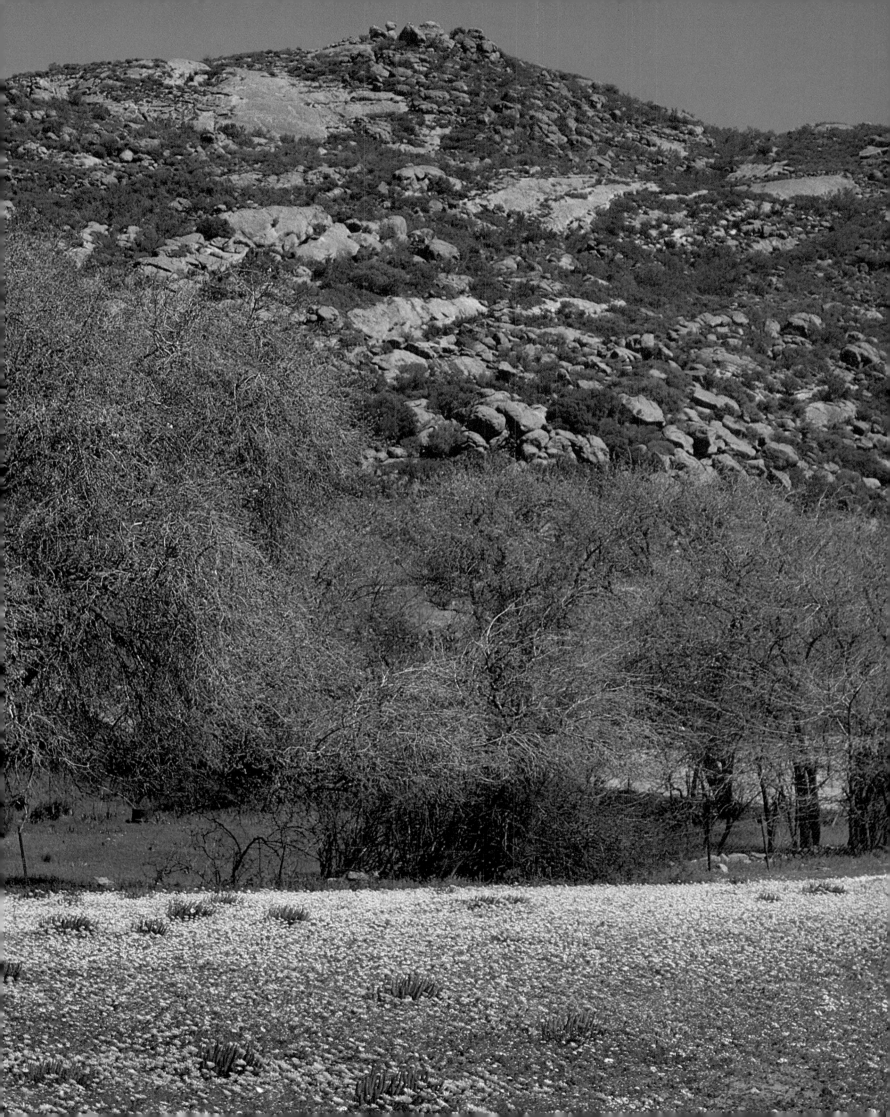

BELOW AND OPPOSITE A Namaqualand spring is unpredictable. One year a single
Lapeirousia stands guard on a koppie. The following year thousands congregate
on the same slope.

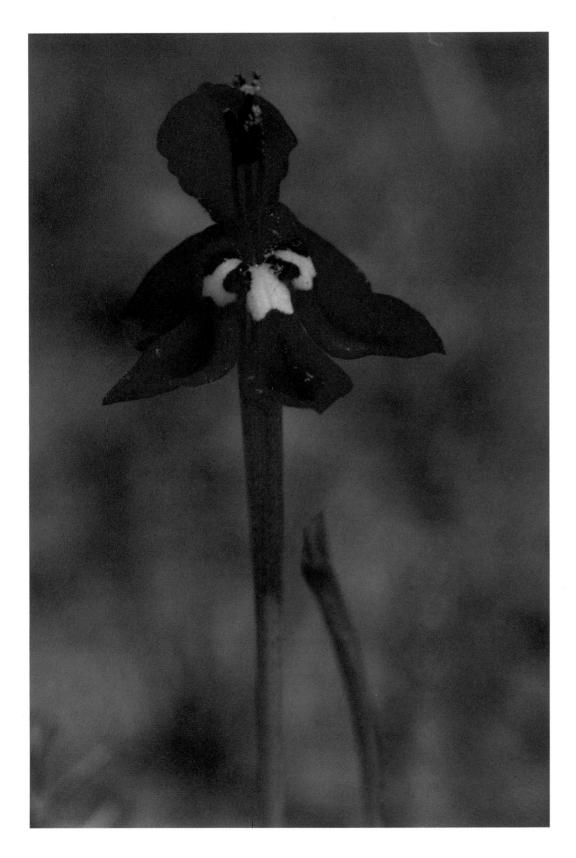

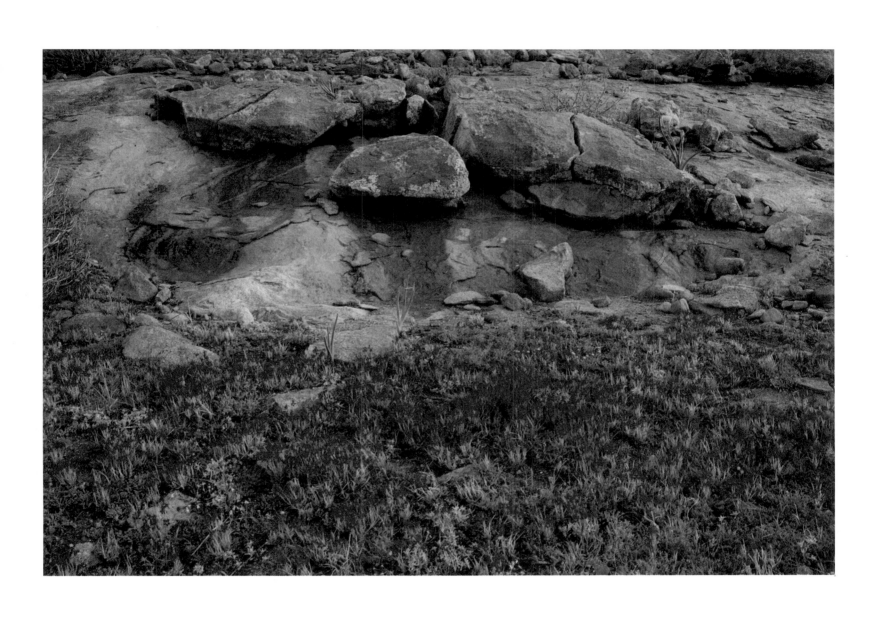

Tiny lichens splash exposed granite with red paint; blossoms of *Silene* peer out of a depression in the same rock like fledgling birds from a nest. Although the lichen and the *Silene* live only centimetres apart, they do not share the same habitat. Yet, each plant form finds its habitat to its liking and is able to reproduce.

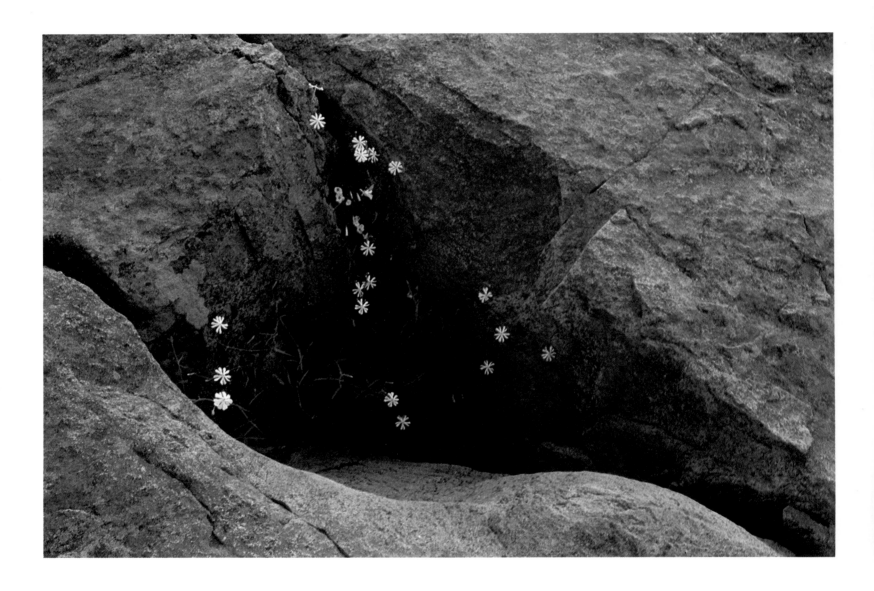

A white shrubby mesembryanthemum, *Aridaria brevicarpa*, opens its blooms on a warm, overcast afternoon. Most Namaqualand flowers that open and close their blossoms daily do so in response to heat rather than to the sun itself. On a cold, sunny day, they remain closed, but on a warm, cloudy one, the flowers open and insects are busy. Flowers that open at night usually release a strong fragrance to attract insects, because the colours and shapes of the blossoms cannot be seen.

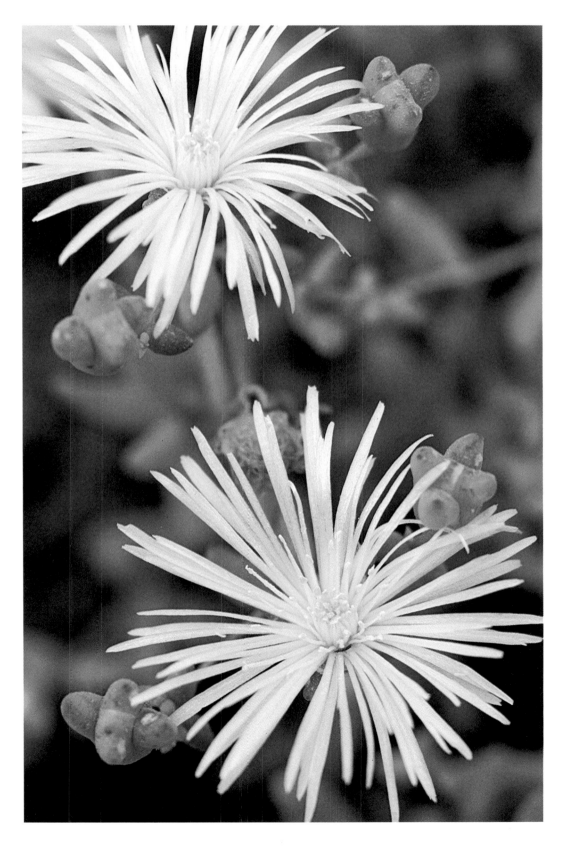

The delicate hues of *Hermannia trifurca* are never more beautiful than on a cloudy day, when soft light reveals their subtle variations of colour. On a sunny day, strong black shadows in the bush compete for attention with highlights on the blossoms.

The person who comes across *Microloma sagittatum* for the first time may think it's a shrub, because this slender perennial herb twines itself around the branches of shrubs for support and is often difficult to distinguish from them. Only a close examination will reveal two separate plants and show that the barely-opened red blossoms belong to the climber.

Plants and other natural things

Rain is manna from heaven in Namaqualand, indeed in much of southern Africa. In semi-arid and desert ecosystems, the struggle among plants is not for light and space, but for moisture. The relatively equal spacing between desert shrubs reveals how much territory each plant requires for obtaining enough moisture from the soil in its particular locality. In Namaqualand, you can estimate the amount of moisture available by noting whether shrubs are close together or far apart.

Desert shrubs are drought resisters. They have evolved ways to locate moisture underground, or to store rain water, or have altered their structure to reduce their need for it. Some are woody plants with enormous root systems that not only collect water, but anchor the soil and prevent erosion. Others are succulents with waxy stems and leaves that store moisture and reduce evaporation. Many of the ways Namaqualand plants have adapted their structures to resist drought are so ingenious that it's easy to credit them with active intelligence.

Massonia depressa is such a plant. It's a lily, a perennial herb that stores moisture in a bulb, like many other Namaqualand plants. This gets it through the driest of seasons. However, there's more to the story. *Massonia* puts out only two leaves, which are broad and lie absolutely flat on the ground. Air in pockets under the leaves is trapped during the cool nights and remains warmer than the air above, causing tiny water drops to form on the underside of leaves, providing moisture for the plant. But, during the day, the leaves act like mulch by shading the soil around the plant and reducing evaporation. The *Massonia* blossom is a circular mound of tiny florets at the junction of the two leaves. Since the flower head has no exposed stem, water does not evaporate as it travels from the bulb to the flower.

Other members of the lily family have evolved equally unique structures for the battle against drought. Take the "kokerboom" or quiver tree. If *Massonia* is small, the kokerboom is huge. It's a lily that grows up to nine metres tall, and is called the kokerboom, or quiver tree, because the nomadic hunters who once inhabited the area where it grows used the bark from its branches to make quivers. This plant resists drought by developing a thick trunk with a tough bark and narrow succulent leaves. No matter how hot the sun or how strong the wind, little moisture is lost. The quiver tree punctuates the horizon like a beacon, a Namaqualand trademark.

The irises of Namaqualand make up a large and very beautiful family of plants. Among them is the *Moraea* genus, each species of the genus resisting drought through rather fanciful leaf variations that reduce the area exposed to drying winds. *Moraea tortilis* has two or three basal leaves that are extremely narrow and coiled like a corkscrew. *Moraea serpentina* looks like its cousin, except that its flower is yellow and white, not pale blue or mauve; it has leaves that are less tightly curled than those of *Moraea tortilis*, but are even narrower, so very little surface is exposed to the air. *Moraea fugax* has only one leaf, which is very long, extremely thin, and resembles a limp needle. These and all the other

irises, including the wild gladioli, the ancestors of our spectacular garden hybrids, have corms for water storage.

Except for the shrubs, which are often beautiful in masses, the drought-resisting plants are more striking as individual flowers or in small clusters; they are the visual spice in the floral menu. But what makes spring in Namaqualand a spectacle worth news announcements are the annuals, especially the daisies, and some perennials. These plants don't resist drought, they evade it. They are so successful that, when enough rain falls, they transform the earth. Since moisture is available for only a short time, plants must concentrate their floral activity into one brief season.

In a good year, the fields and koppies around Springbok abound with gold and orange *Osteospermum*. So does the town itself. A valley high in the Kamiesberg may be a solid orange mass of double or single Namaqualand daisies, *Arctotis fastuosa* or *Dimorphotheca sinuata*, but so may many other parts of Namaqualand. Sheets of white sporrie, *Heliophila variabilis*, which stretch over hectares, may suddenly be edged with a broad blue band of *Felicia*, which separates the sporrie from an equally large floral quilt-of-many-colours. Ploughed fields on the mountain plateaus, lying fallow for a year, become clouds of orange, white, yellow, azure, salmon-beige, or pink that drift across the landscape. Every foot-step means crushing dozens of golden *Cotula*, mauve *Felicia*, or banded *Ursinia*. Brick-red beetle daisies, *Gorteria diffusa*, and silvery-yellow *Grielum humifusum* are very common. These grand displays do not occur everywhere, nor in any one place with absolute regularity, but it is a rare year when they don't occur some-where. Everything depends on the amount and timing of rainfall.

The drought evaders survive the dry periods as seeds. They seem to do best in sandy soil that absorbs moisture readily and warms up quickly, and they are just as innovative as the drought resisters. The seeds of many drought evaders are coated with a water-soluble growth inhibitor, and they will not germinate until there is enough water to dissolve the inhibitor or wash it away. One to four centimetres of moisture in the soil is usually sufficient for them to germinate, establish roots, grow quickly, bloom, and set seeds before a new dry period commences. Because of the growth inhibitor, these species will not sprout after a trivial shower, when moisture would not last long enough for them to complete their life cycle. However, different species require different amounts of water to stimulate germination. Some seeds will sprout after a single heavy rain. Others need several rainfalls. Still others germinate only after years of dormancy.

Like plants, desert animals are either drought resisters or drought evaders, although most practise evasion. Those forms of animal life that require a regular food supply, such as the jackal, are usually active early and late in the day, or at night, when the heat is less intense. Others, such as rodents, burrow under-ground where temperatures may be 30° or 40°C cooler than on the sun-baked surface of the soil. But many creatures – insects, amphibians, and mammals – can survive long periods without food, and aestivate during the dry seasons, thus conserving energy and body moisture. Some birds also become less active if drought is extended. For months, even years, insects and their eggs remain dor-mant in the soil, to emerge only when sufficient rain penetrates the earth. If you are present in Namaqualand when rain comes, you may witness insects emerging at precisely the same time as the flowers they feed upon come into bloom.

In Namaqualand insects are important, so important that many flowers open only when it is warm enough for insects to fly about and pollinate them. Or, from the opposite perspective, the flowers are so important to the insects that the insects fly around only when there are flowers available for nectar. Whichever

way you look at it, the mutual relationship is essential. Because the nights are cold in spring and it takes a while for the air to warm up in the morning, these flowers don't open until about 10:00. By then, the pollinating insects are also ready for action. But everything is delayed if there's a chilly wind blowing, or if a cloud cover keeps the temperature down.

Plants lure insects with flowers. By the shape, colour, and markings of its blossoms, a plant identifies a landing strip for the appropriate insect, tells it where to touch down, and how far to taxi. If the insect follows instructions, it receives a load of nectar as a reward – but it also gets a cargo of pollen. The insect transports these male cells directly to the female cells of another flower of the same species (since it uses the same lures). This mode of delivery is far more efficient than water transport. In Namaqualand, where moisture is often unavailable for transporting male plant cells, insects ensure fertilization and the continuing display of flowers.

Insects and their relatives are important to plants in another way. They churn the soil. Termites, for example, move considerable amounts of earth in constructing their large, complex mounds, opening up spaces in the ground where moisture can collect. In Namaqualand, termites and other insects, as well as small mammals, create underground cisterns that retain water and allow infrequent rains to penetrate deep into the subsoil, rather than to run off the surface.

Because of differences in moisture, heat, soil type, and other factors, the plant communities vary throughout Namaqualand. The vegetation at the coastal village of Kleinsee, for example, is substantially different from that in the mountains around Leliefontein. In all areas where cultivation takes place, plant life is directly altered. Even when fields are left fallow for decades, the changes caused by cultivation may remain apparent, because no part of Namaqualand receives sufficient moisture to spur the rapid re-establishment of natural vegetation patterns. However, all the barren areas of Namaqualand – dunes, rocks, new rock cuts along highways, and fields just removed from cultivation – are natural vacuums that will eventually be colonized by living things, and it's possible to observe such areas at many different stages in the long process of developing a mature, or climax, natural vegetation. For example, the exposed, bare rocks of the koppies are colonized first by crustose lichens that form intricate black, red, and greyish patterns, often as lovely in their own way as any of the wildflowers. You can find these lichens on rocks all over the Kamiesberg range. While they don't modify rock surfaces chemically, some of them provide sufficient roughness or texture to catch dust and other fine particles. In this way they can help to collect material that will be blown or washed into crevices or depressions, so other plants can take root. The higher plants, like *Ursinia* and *Pelargonium*, which become established in these accumulations of dirt, are usually a chance assortment of species from surrounding areas. They have a greater impact on the rock surface – especially woody shrubs such as *Wiborgia*, whose roots may reach deep into a crack, exert pressure, and help to enlarge the fissure. However, winds are often so strong in Namaqualand that small accumulations of soil are blown away, exposing the rock again. In places where this happens and on vertical or sharply-sloping rock faces, the lichens persist indefinitely, and time seems to stand still or to move at a pace incomprehensibly slow to the human mind.

At the base of the klipkoppies, pulverized rock, sand, and organic debris provide a much better rooting medium than elsewhere; consequently, vegetation tends to be much thicker and more varied there – when there is sufficient moisture. There you can study the more rapid development of plant communities.

Similar situations that are very easy to observe can be found all along the main highway through Namaqualand. In many places the road has been blasted through rock, and these new roadside cliffs show both the bare-rock habitat and the accumulation of material at its base. By stopping your car and observing one of these rock cuts for a few minutes, you can learn a great deal about what plants require in order to survive and how they can alter their habitat once they have become established. You'll also be able to make many fine pictures of plants in these locations.

Sand dunes are another common "primary" site for plants in Namaqualand, especially on the coastal strip known as the sandveld. You can find bare dunes, dunes that have a fairly dense plant cover, and various intermediate stages. Plants stabilize dunes, but they can do this only if they have enough moisture to grow. If wind, heat, and the type of sand cause rapid evaporation, plants will fail to hold the soil. Grasses are the most successful pioneer plants on dunes, and if they become established, other types of plants can move in more readily. But, where there are no grasses, it's more difficult for the others to gain a roothold. If you should visit the sandveld, look for examples of plant succession on dunes, and try to determine which areas are partly or fully stabilized – and why. By visiting several locations and photographing various plant species, you can record something of the history of a dune's development into a permanent home for plant and animal life.

While Namaqualand is widely known for its spectacular displays of wildflowers, it deserves to be better known for the many ways all kinds of plants have adapted to its semi-arid and desert environments. When you come to see the flowers, keep your eyes open for a more complete story as well. Look for examples of drought resistance and drought evasion among plants; watch for plants and insects co-operating for mutual benefit; and observe how plants influence the development of the land itself.

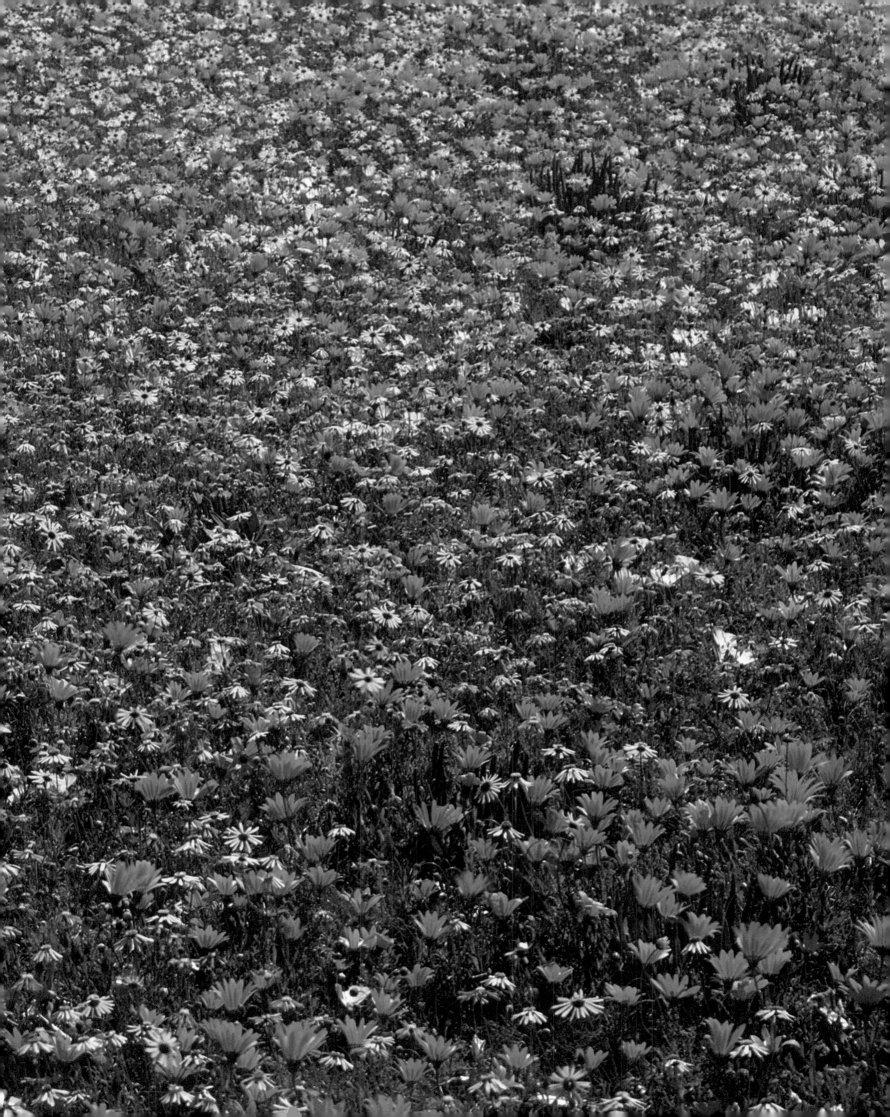

PRECEDING Flowers beyond counting carpet a mountain meadow at the height of spring on the Kamiesberg plateau. Every few metres the pattern changes; sometimes one hue dominates, sometimes another, or they can all be scrambled together in a wild mix beyond any perceptible order.

OPPOSITE AND BELOW A flower-swept Namaqualand hillside is a wonderful place to become a child again. Children know that there are more ways to see flowers than from our adult perspective. They become involved – rolling, crawling, and poking their noses into blossoms – delightfully lost in colour and fragrance, perhaps of yellow *Senecio*, or hongerblom (opposite), *Arctotheca calendula*, or soetgousblom (below).

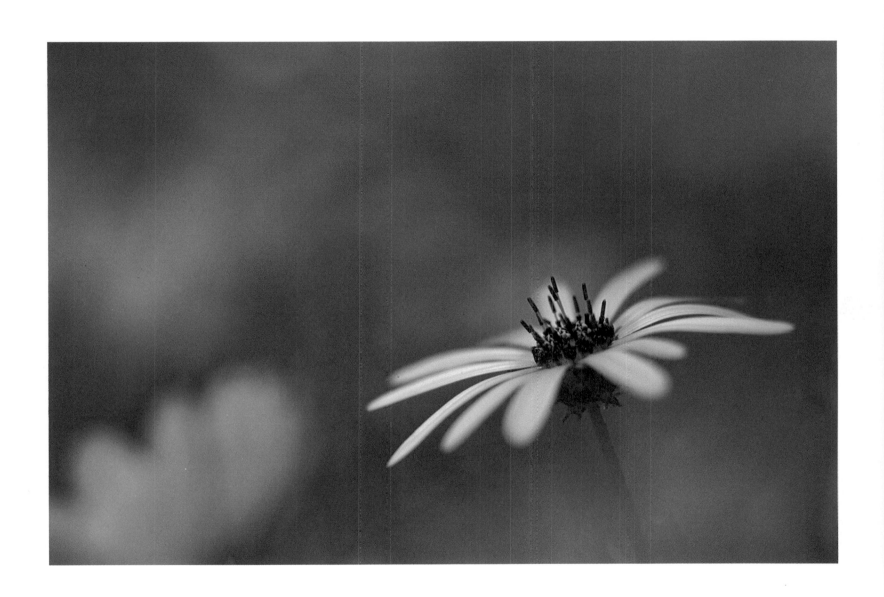

BELOW It is the lure of the unexpected that draws visitors to Namaqualand in spring. Even in years when flowers are scarce in most places, the diligent searcher will eventually be rewarded with spectacles like this.

OPPOSITE A kokerboom, or quiver tree, *Aloe pillansii*, punctuates the horizon in the Richtersveld. Ranging north from Garies into Namibia, kokerbooms are especially common near the Orange River, usually growing on hot, north-facing slopes, often among boulders, and in the most arid regions. The kokerboom is a lily that blooms in winter—June and July—its yellow candles set in candelabras of waxy green leaves at the end of branches.

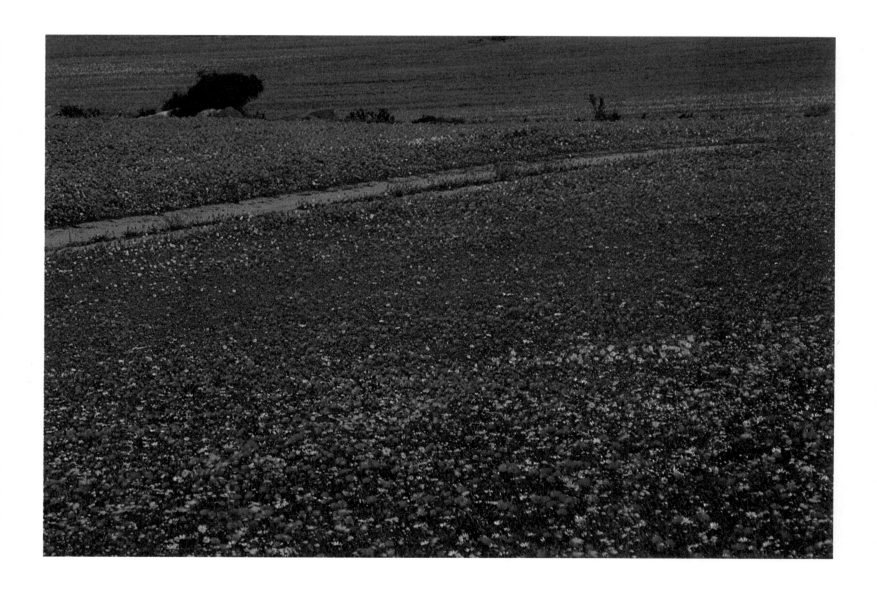

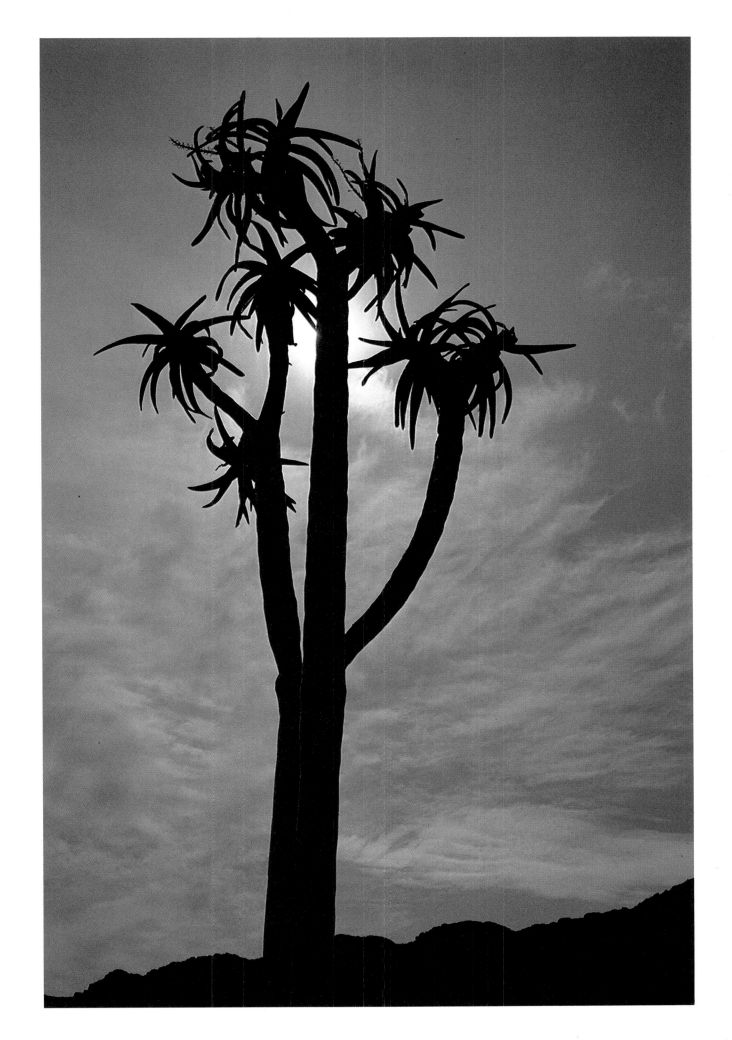

BELOW In a year when heavy winter rains continue into September, water will lie on flat fields for a few days, making the soil so saturated that to drive off a hard-packed vehicle trail is to become mired. This is the time to remove your shoes and to feel the warm water and mud on your feet, as you wander through the flowers.

OPPOSITE Photographers who wander fields such as these will find a wide-angle lens helpful in showing flowers close up while revealing their sweep across the land. It helps to forget your usual perspective; instead, crouch down and move in closely on the foreground blossoms like these yellow mesembryanthemums, *Cheirdopsis pulverulenta.* Then tilt your camera up again just enough to reveal a sliver of sky.

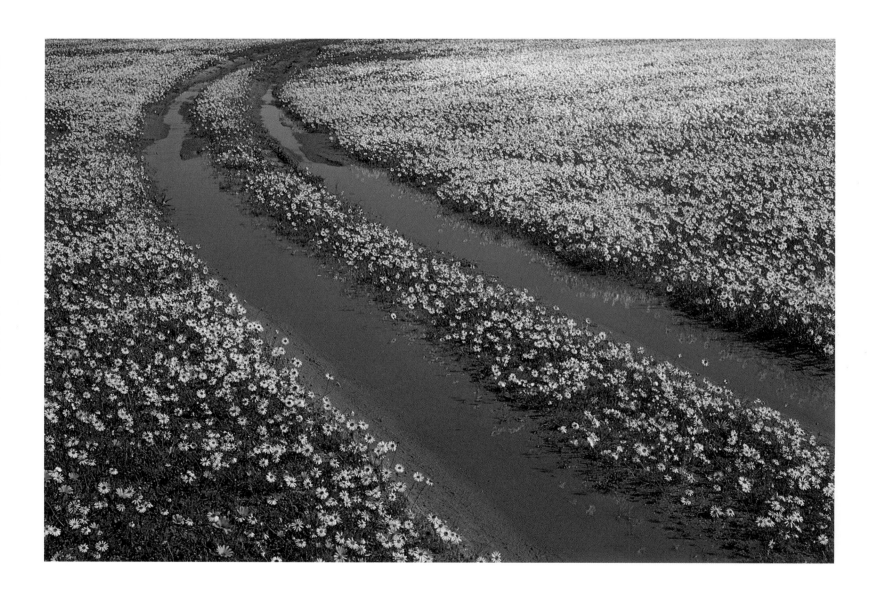

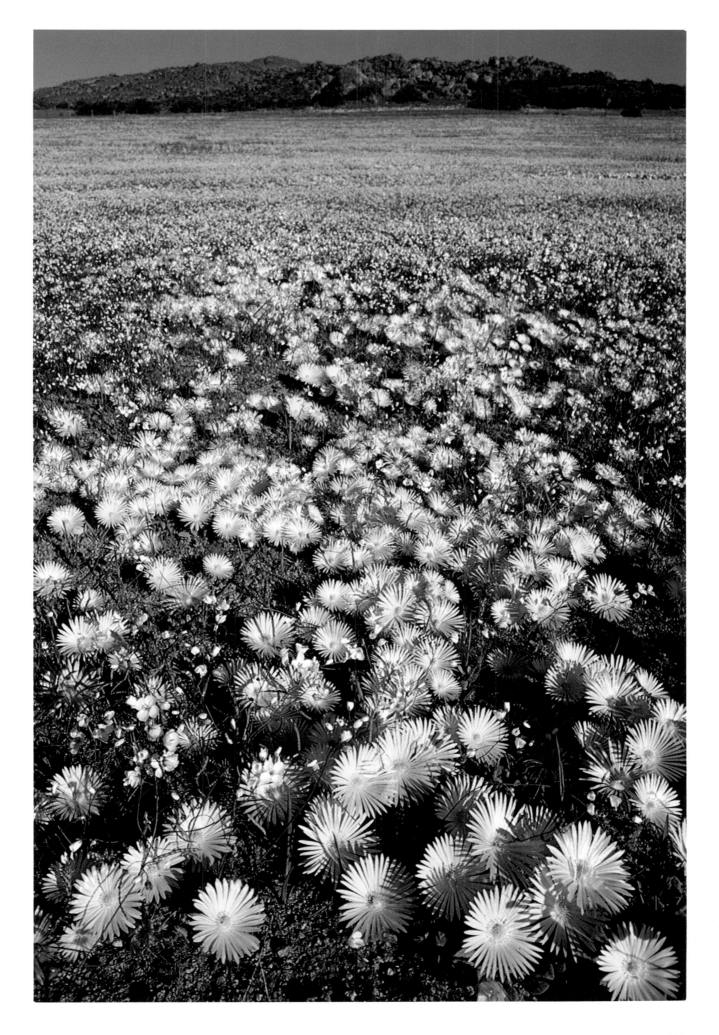

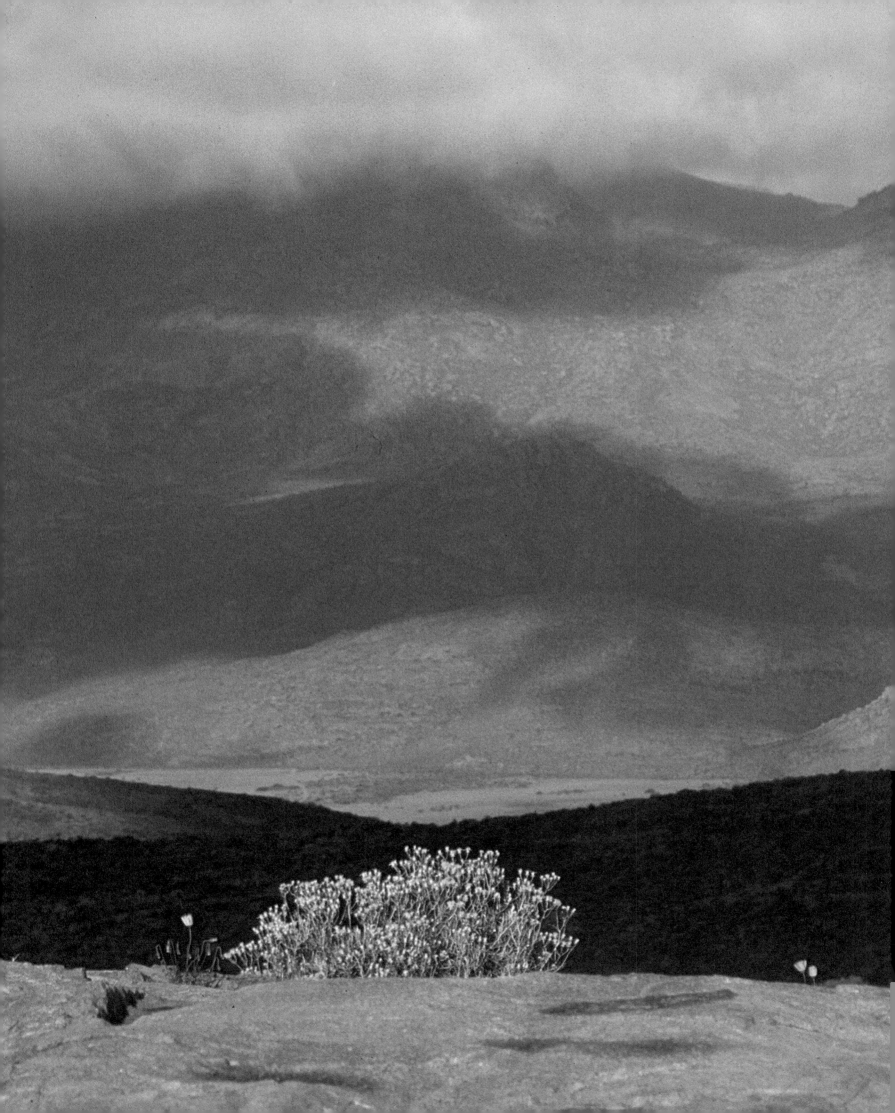

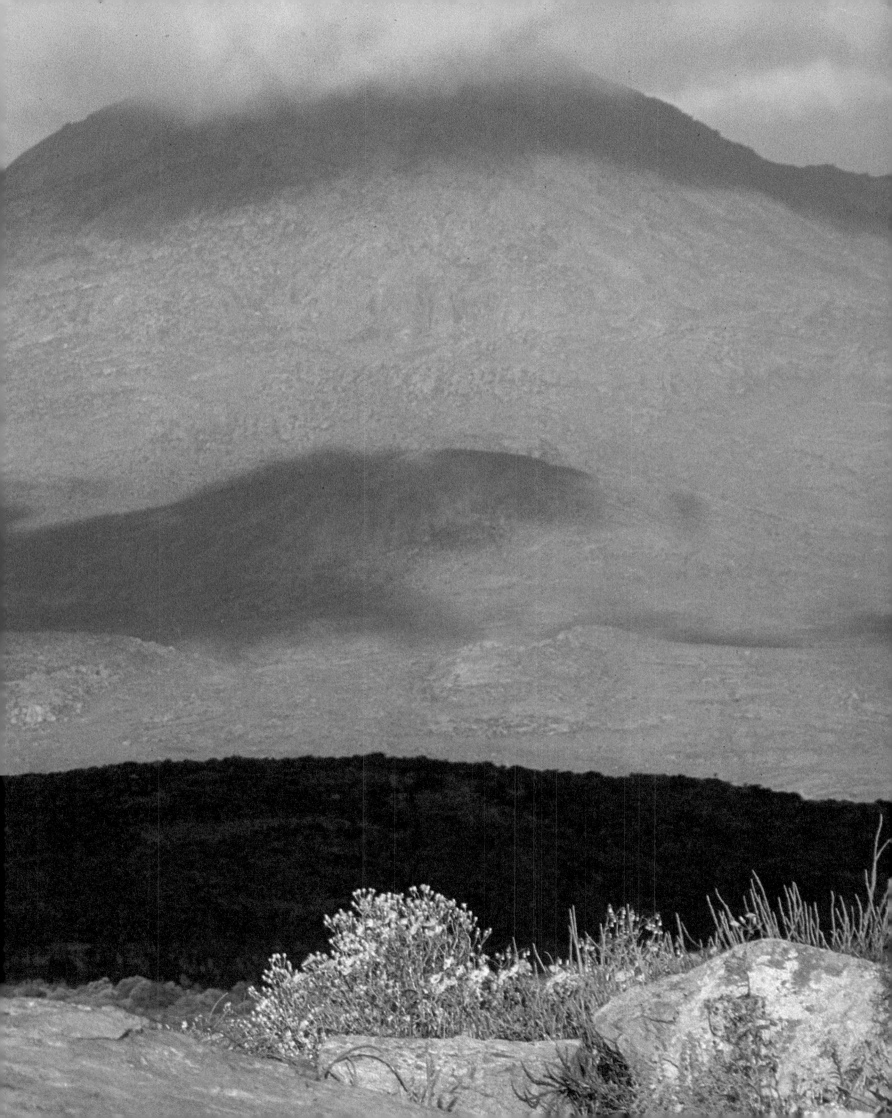

PRECEDING Light and shadow play across wild and lonely hills – a graphic reminder of the struggle between the bitter chill of winter and the gentle warmth of spring. This is a land of extremes, where days of silence are followed by nights of wailing wind, where cold bites to the bone and heat sears the skin, and where scenes of desolation are transformed by the miracle of sudden and abundant life.

BELOW AND OPPOSITE Flowers live in our dreams and reveries as symbols of perfect beauty. In our imagination we forget the insect-scarred leaves and withered blossoms, and picture instead the reality for which we long. Our ability to conceive of perfection in an imperfect world gives us hope and courage. We are able to believe that, like flowers buffeted, beaten, and scarred by external forces, we can still attain moments of excellence and beauty. The flowers of Namaqualand are tangible evidence that our dreams are neither impossible nor foolish.

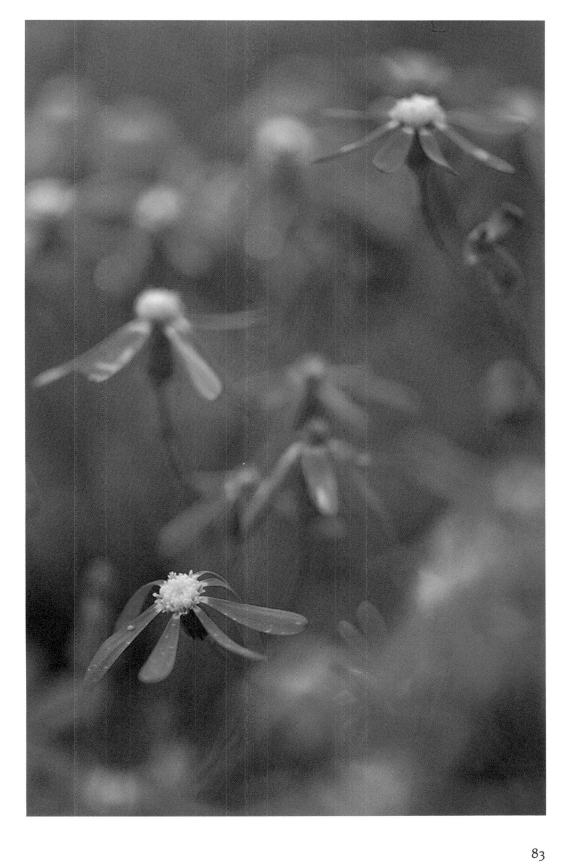

Namaqualand has many tall and stately lilies. This one reached a height of more than a metre, perhaps because it was growing at the edge of a stream, and thus had a fairly steady supply of moisture during the winter and spring.

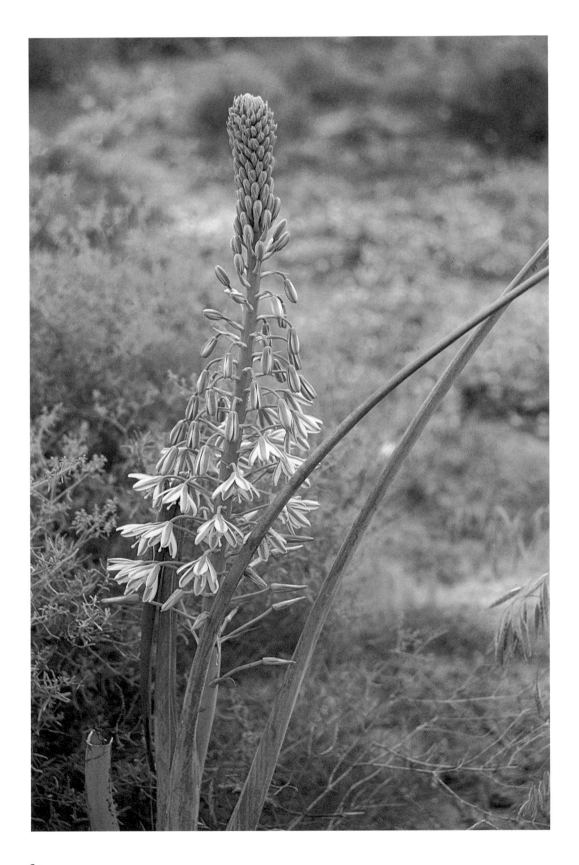

As a spring storm dissipates over the central highlands, a lingering cloud darkens the face of a mountain. Far below, sunlight illuminates a golden scatter-rug of *Cotula*. The stark contrast between light and darkness is a Namaqualand metaphor, expressing the hope and despair of those people who live off the land.

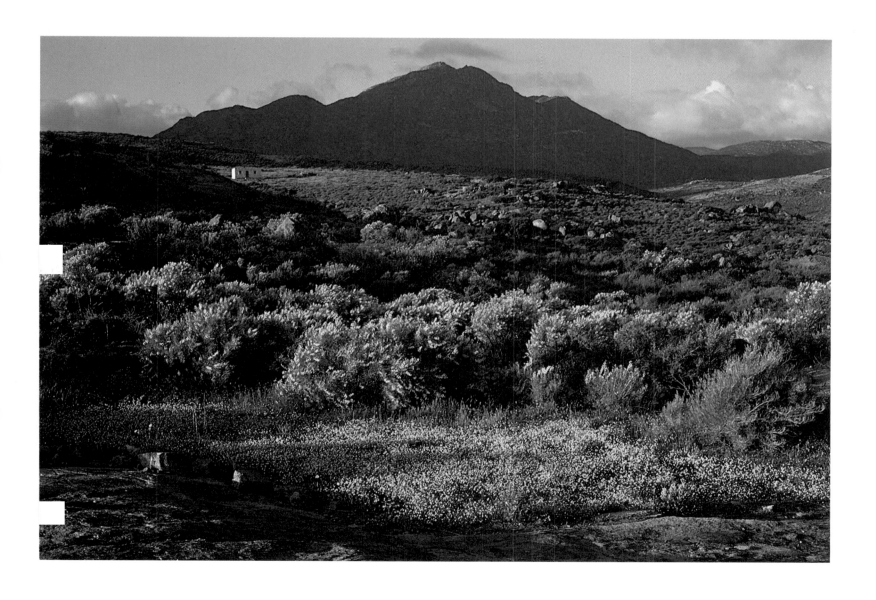

Common throughout Namaqualand and much of southern Africa, *Gazania leiopoda* blooms in a temporary puddle. This species has countless variations of hues and intensities.

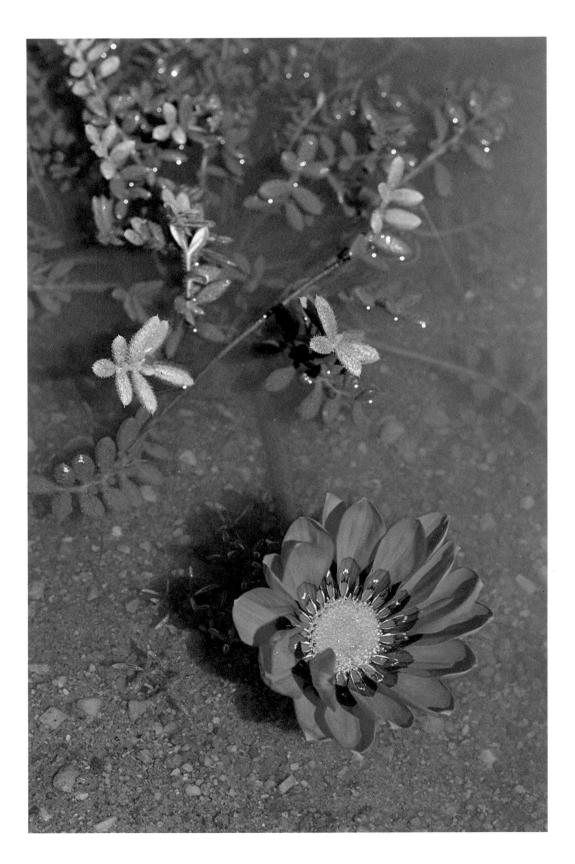

Euphorbia mauritanica is a common succulent shrub that also grows in other parts of the country and in Namibia. However, a bush in bloom has an unusual quality about it; a second and third look are not enough to solve the puzzle of its peculiar appearance. This bush, growing on the veld south of Bitterfontein, has its "own" territory. Like many desert shrubs, it has cleared a space around itself by depriving nearby plants of moisture in the soil.

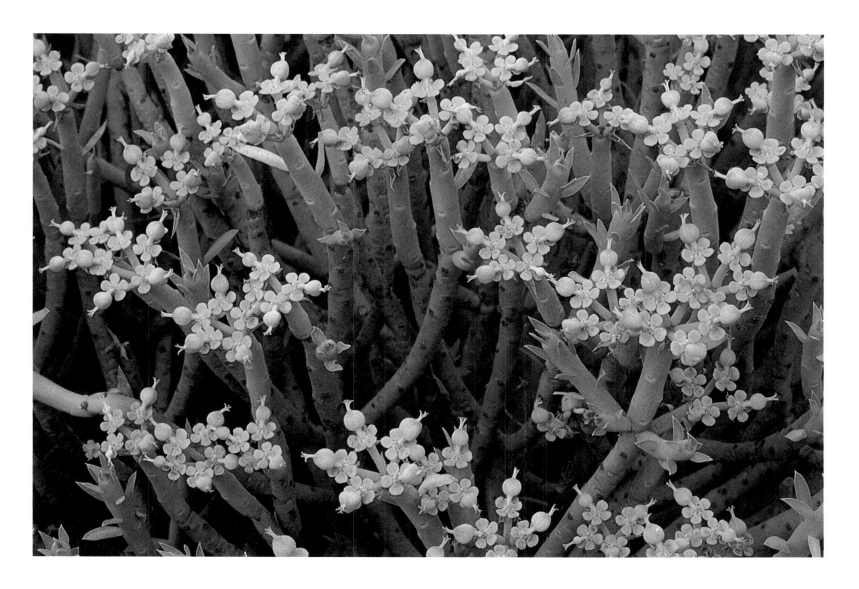

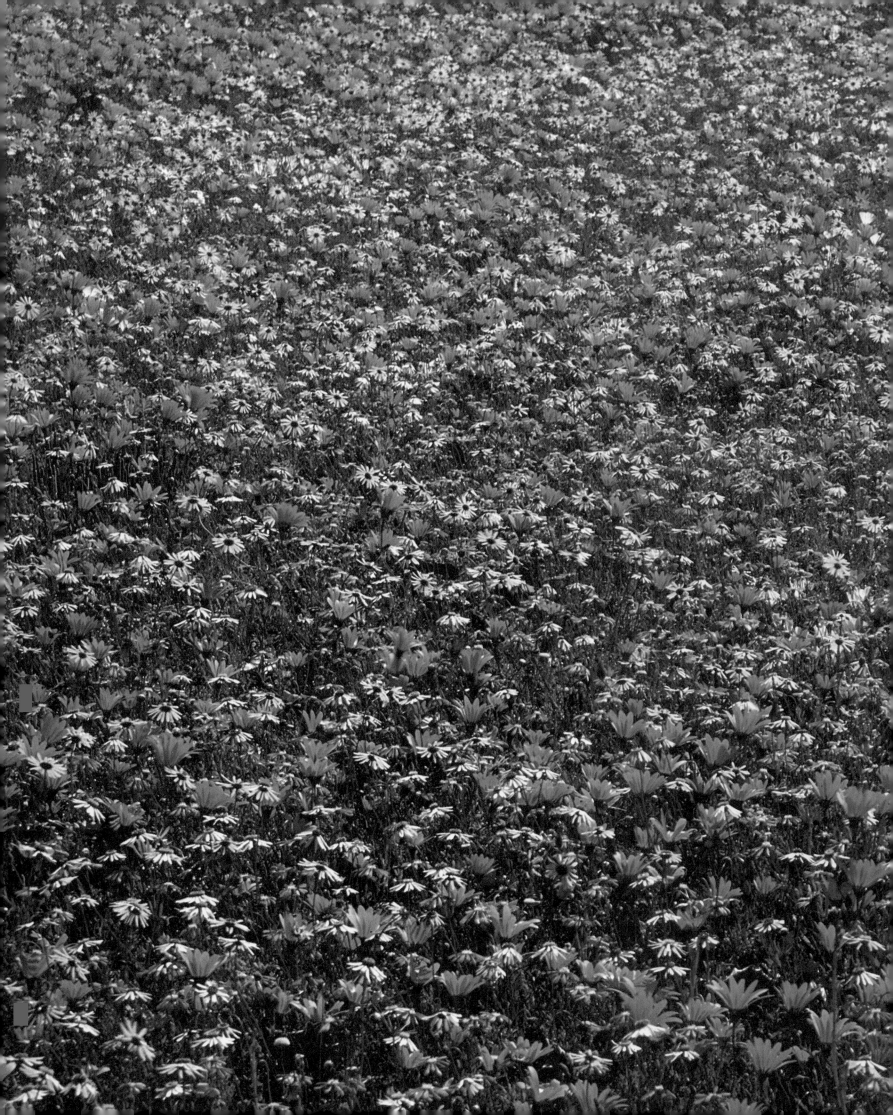

Photographing the land in bloom

There is no better way to see Namaqualand's wildflowers – to really see them – than to photograph them. Making pictures of the flowers focuses your attention. Besides the grand sweeps of colour, you begin to notice the transitions from one hue to another – the interfingering of yellow with mauve, and mauve with white. You become aware of splashes of pink on rock faces, of long yellow lines twisting and swirling through sloping fields, following the pattern of natural drainage. You become sensitive to the weave of the floral fabric, singling out the myriad rainbow threads. You see tiny individual blossoms, the drops in an ocean of colour. And, you become excited by a single plant crouching in the shelter of a boulder.

The more you begin to see, the more you become involved, not only with the stunning natural designs of whole fields or with individual blossoms, but with nature itself. You start to ask why this klipkoppie is rimmed in scarlet, why that one flows with orange; you wonder why a particular blue iris favours rock crevices and why a yellow one prefers dry, sandy soil. Your thoughts easily range beyond the colourful blossoms, to the incredible variations in the leaves of Namaqualand's plants, to seeds and how they are dispersed, to the kind of soil and the amount of moisture that various species require. Almost before you know what's happening, you become a keen observer in two ways – an artist concerned about visual relationships and a naturalist intrigued with relationships in nature – and you begin to understand the connections between the two. Then, Namaqualand becomes very special indeed.

You'll find that your picture-making leads you down both paths. Sometimes you'll use your camera to record a field of Namaqualand daisies stretching to a distant horizon, or to document the structure and colour of a single viooltjie. Other times you may endeavour to convey the mood of spring or to express feelings that spring and the flowers evoke; or you may single out natural floral designs and patterns, losing yourself in abstract configurations of colour and form. By employing both visual approaches to the photography of Namaqualand's flowers – the documentary and the interpretive – you will be able to make a wide variety of pictures. You will tell the story of the flowers effectively and convey your response to them as well.

Regardless of which approach you take in any particular situation, you should observe and photograph the flowers from several points of view. You may simply want to aim your lens at a hillside or a field of flowers and shoot. However, while it's important to have overall pictures of the land in bloom, also consider the beauty of less distant images, perhaps a line of ursinias winding up the side of a klipkoppie, or the mass of blossoms in a small section of meadow. Then move in closer for compositions of crimson gazanias grouped at the base of a termite hill, or with a wide-angle lens move close to a cluster of yellow vygies to make them stand out in front of a field of white daisies that sweeps away behind them. Select a macro lens or other close-up equipment to focus on a single flower, perhaps a blue felicia or a magenta lapeirousia, to show the pattern of its petals or the colour markings that attract insects.

Don't forget to look at the flowers from their perspective – some of your most exciting images will be made with your camera at or near ground level. Poke your lens into a waving mass of blue sporrie so the flowers brush against the lens, while you focus through them on orange daisies a metre or more away. Then, focus closer, so both the sporrie and orange daisies become soft halos of colour around a golden oxalis. For good photographs of the flowers – and sheer enjoyment – experiment with many different camera positions, lighting conditions, and lenses. Abandon yourself to the sense of freedom the flowers evoke. Let yourself go!

If you start with a 35mm single-lens reflex camera and a standard 50mm lens you can follow most of these suggestions, but if you have two or more lenses you will be able to make an unlimited variety of pictures. Consider any of the following combinations: 1/ a 50mm lens, a 100mm macro lens (for close-ups and overall shots), and a wide-angle lens; 2/ a 50mm lens, a wide-angle lens, and an 80-200mm zoom lens with macro capability; or 3/ a 50mm macro lens, a wide-angle lens, and an 80-200mm zoom. There are other similar useful combinations.

For consistently good pictures of the flowers, you should also have a sturdy, light-weight or medium-weight tripod. If you use a tripod, you will find yourself composing your photographs more carefully – examining edges and corners of your pictures to make sure that no distracting material is included. Often the difference between a mediocre photograph and a good one is just a slight adjustment of camera position. A tripod gives you time to think and to make careful changes. Also, it holds your camera steady. I use a tripod for making almost all of my pictures, including those in this book.

Here's what to look for when you buy a tripod. 1/ Sturdiness. A tripod should support your heaviest lens and not tremble in the wind. 2/ Ball-and-socket head. Most tripods come with a pan head, which is for movie cameras. Remove this in the store and replace it with a ball-and-socket head that will support your heaviest lens. A ball-and-socket head makes working with a tripod a pleasure. 3/ Legs that spread flat. This allows you to work with close-up equipment at or near ground level. Test all features of the legs for ease of operation before you buy a tripod. 4/ Standard or accessory short centre post. You will need a short centre post when the tripod legs are spread flat. 5/ Size and weight. For walks or longer hikes, consider a tripod no longer than 56 centimetres and weighing about two kilograms. If a store does not have a tripod with these features, don't accept a substitute. Order the one you need.

There's very little additional equipment you'll need in order to photograph Namaqualand's flowers well. A ground-level or right-angle attachment for your viewfinder will make photographing at ground level much easier, because you will be able to compose your pictures without having to lie flat or to twist your neck in order to see. Bring a spare battery or two for your camera, and a piece of silver kitchen foil to reflect light into shadows or dark areas of flowers that you are photographing close up. Put an ultraviolet or skylight filter on your lenses for protection from blowing sand and dust, and for reducing the blue tint that sometimes occurs in photographs made on bright sunny days. One other filter that can be very useful is a pale blue cooling filter (perhaps an 82A or 82B filter); you may want this for photographing blue flowers, because colour films will often render these as purple or pink, rather than the way they appear to the eye. You won't need an electronic flash unit (all of the photographs in this book were made with natural light), but if you already have one you can use it to "correct" the colour in close-ups of blue flowers or to arrest movement in blowing plants. Don't forget to take your second camera, if you own one.

Bring your favourite films, but if you are uncertain about which ones are best, test two or three brands ahead of time by photographing flowers near your home. For example: 1/ Buy twenty-exposure rolls of three brands of film. 2/ Select four or five different arrangements of flowers in a nearby garden. 3/ Using your various lenses, photograph each of these arrangements with each brand of film – with as little delay as possible, to get similar lighting conditions. 4/ Compare the results. Then you can settle on one brand of film for most of your shooting, and bring a few rolls of a second brand along for specific situations – perhaps a fast film for photographing in low light or very strong wind.

The quality and direction of light will have a major influence on your photographs of flowers. The quality of light refers to its harshness or softness. Harsh light emanates from a direct light source, such as the sun in a clear sky. It produces strong highlights and shadows. Soft light comes from an indirect light source, such as the sky on an overcast day. It's also what you find when photographing flowers in the shade. Soft light produces much more gentle contrasts and is wonderful for flower pictures, especially close-ups. However, because most spring days in Namaqualand are sunny, let's consider direct light first.

When the sun is shining brightly, you will want to consider the direction in which its rays fall on your subject matter. Are the flowers front-lighted, side-lighted, or back-lighted? Front lighting (the sun is behind you, but falling on the front of your subject matter as you face it) is often the least interesting direction, because the shadows fall straight behind the flowers and other objects in your picture. Scenes and medium-distant shots may appear a little flattened, slightly dulled, and lacking in texture. However, contrasts of colour will help to overcome this. Side lighting (the sunlight is entering the picture space from either side) produces good texture and shadows that may be useful in the design of your image. When side lighting shines through translucent petals, it seems to enrich and brighten the hues. Back lighting (the sun is in front of you, and its rays are falling on the back of your subject matter) emphasizes shadows, outlines shapes strongly, and like side lighting can make the colours of translucent flowers sparkle and glow. With back-lighted compositions, you must remember to *underexpose* from what the camera's meter indicates, if you want to avoid overexposing the brighter areas. However, if you want detail in dark areas and aren't worried about overexposing highlights, then follow your meter. With all three directions of lighting, remember that the meter is indicating an *average* exposure, so don't hesitate to overexpose a little for more delicate effects, or to underexpose a little for more saturated hues. Make use of the manual over-ride feature on automatic cameras, or be satisfied with a non-automatic model, if that's what you have.

Clear, sunny weather provides marvellous opportunities for photographs of flowers early and late in the day when the light is warm and the shadows are long. Rise early to take advantage of it, and linger on the veld and the klipkoppies until the sun sets. It's a popular myth that the flowers of Namaqualand open late in the morning and close in the middle of the afternoon. While many annuals observe this schedule, you should not. Take along a snack, stay out as long as you can, and photograph vygies, lilies, irises, ursinias, and daisies glowing in the sunrise or sunset. You will find that many perennials and some annuals open their petals very early in the day and close them very late, or perhaps not at all, and you will make many of your finest flower pictures at these times.

Overcast days are just as good for photographing flowers, because contrasts are less harsh and colours seem to glow. Many flowers will open, especially

if the day is warm, because even the most reticent annuals respond to heat rather than to the direct rays of the sun. However, many blossoms are just as attractive when they are closed, and by photographing them you are also recording one of nature's important relationships. Ask why some species close up when it is cool, and make the answer part of your picture story.

On rainy or misty days, you may be able to show blossoms studded with drops of water, or to make pictures of plants beside small streams or waterfalls, again adding to the variety of your flower photographs. About the only time you can't photograph flowers is in a downpour, but heavy rain is not a common occurrence in spring.

Wind or strong breezes may be more of a problem. There are two simple ways you can use wind to your advantage. First, forget about having the plants or blossoms crisp and sharply defined in your pictures. Since flowers regularly toss in the breeze, put your camera on a tripod, use the slowest shutter speed you can for the light available (perhaps 1/15, 1/8, 1/4, or 1/2 second), and record the movement. The blurred flowers will seem to dance on a klipkoppie or leap around a field. Second, use the fastest shutter speed you can (for instance, 1/1000, 1/500, or 1/250 second) and a wide lens opening for shallow depth of field as you focus on one plant or blossom, while throwing the rest out of focus. The in-focus flower will be sharp and distinct, while the surrounding ones will produce an aura of colour. Of course, you can use this technique at any time.

When you're photographing the flowers, try to avoid fixed ways of thinking and seeing. Use appropriate techniques you know well, but always be willing to experiment. Put on old, comfortable clothes so you can easily climb, crawl, or lie down as you look for new perspectives. Pick a small section of field – perhaps only a metre square – and devote a couple of hours to it. Make an overall shot of the flowers in this small area, then use a close-up lens to record each of the species in bloom. Try different lenses and lens openings. Throw blossoms out of focus. Ask how a bird, a sheep, or a bee would see this spot. Look at the spaces *between* blossoms. In short, challenge your visual preconceptions. If you begin to do this, you'll find your enjoyment of the flowers growing and growing, and you'll have both a fine record of Namaqualand in bloom and a personal interpretation of it.

Once you have spent a little time photographing in Namaqualand's wildflower gardens, you will want to return again and again. For photographers, more than for any other visitors, it's a good idea to select one town or village (or at most two) as a base of operations. By making day trips from one place or two, you will return home with a more varied and exciting collection of flower pictures than if you drive quickly all over Namaqualand. Even more important, by going slowly you will really see the flowers and you will feel emotionally restored as well.

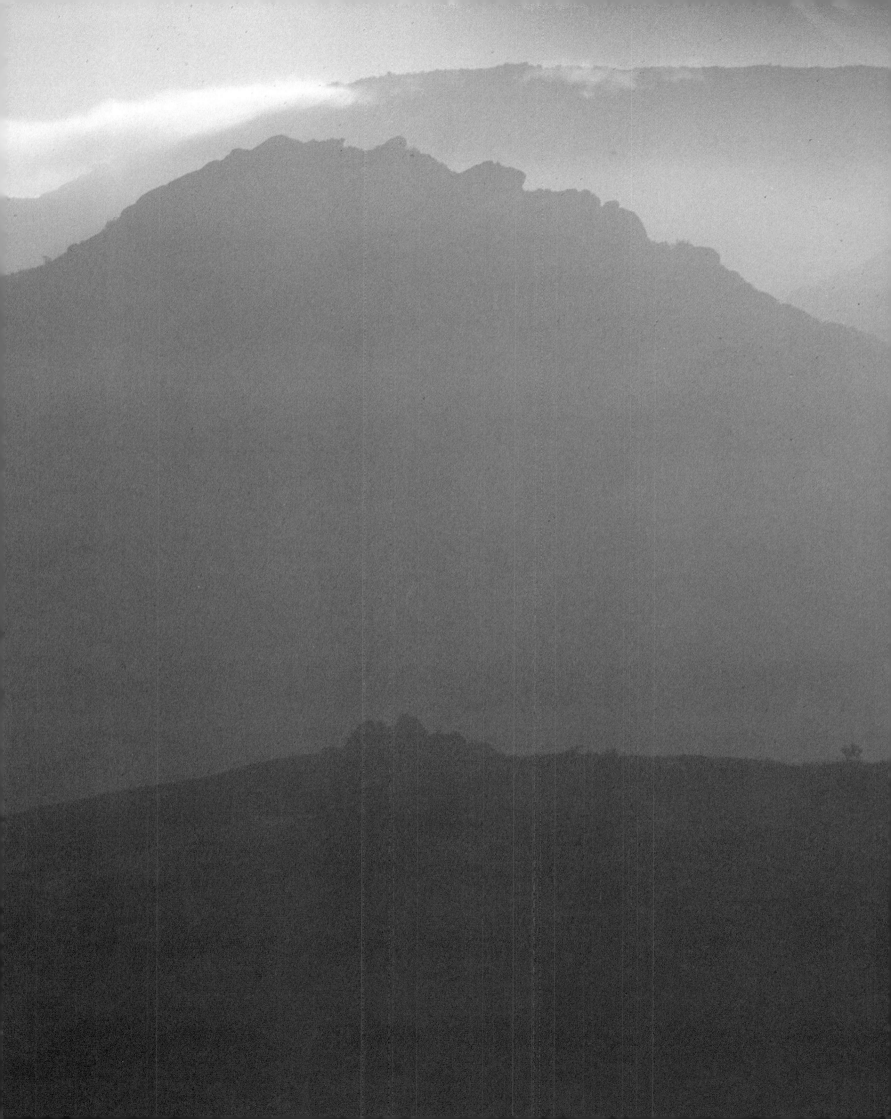

PRECEDING At dawn you can climb a koppie at Kamieskroon and see the garden of the gods enshrouded in mists that have rolled in from the sea. As the mists spread across the sandveld and into the mountains, they moisten and cool the earth, sustaining life of every sort.

BELOW Sometimes it seems as if pieces of sky have fallen on Namaqualand, so vivid are the blues of sporrie, *Felicia*, *Babiana*, and other flowers. On this cool, overcast day, flowers of the blue sporrie remain closed, yet their colour glows in the soft light. Many of Namaqualand's blue flowers can be photographed most successfully when a cloud passes across the sun or on a cloudy day, when the light is soft.

Half-opened blossoms of white sporrie are the focal point of a tiny section of meadow seen from ground level. Although the sun was shining this day, a chilly mountain breeze kept the temperature down, and many annual flowers opened hesitantly or only part way. Insects were inactive, or sluggish at best, until mid-afternoon when the wind abated, the temperature rose, and the flowers opened fully.

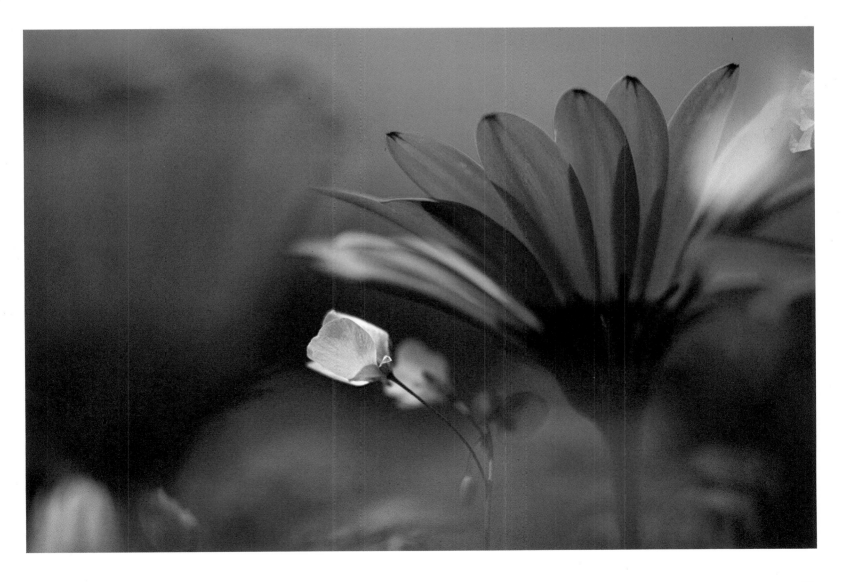

The fields of an abandoned farm in the Kamiesberg take on the hues of spring.
If a herd of goats or a flock of sheep were grazing here, the colour patterns might
be disturbed or eliminated altogether.

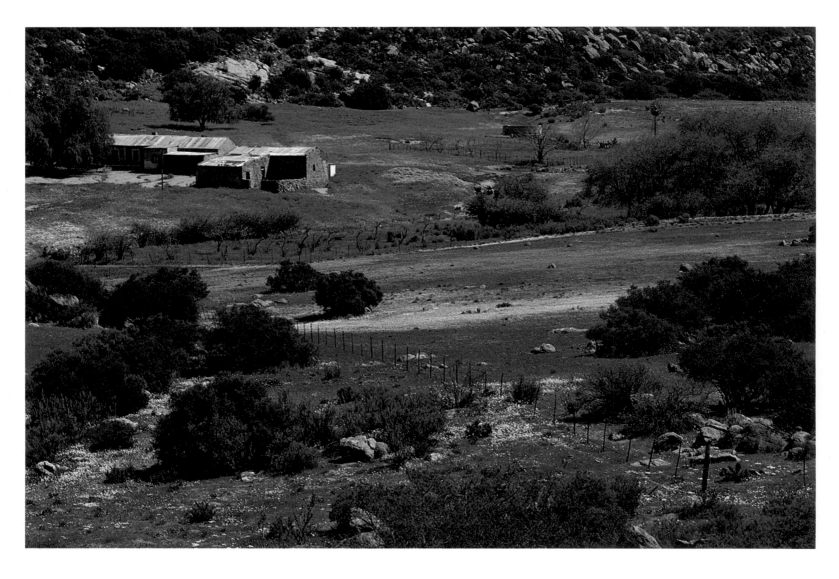

Dry bones are often graphic evidence of prolonged drought. When rains do not fall in their expected season, creatures that cannot migrate, become dormant, or otherwise adapt, face an uncertain future, and many succumb. Yet, only a few weeks later, the same area may be lush with flowers. This is why the farmers of Namaqualand persist and hope through the driest of times; if they can keep their flocks alive only a little while longer, then maybe…

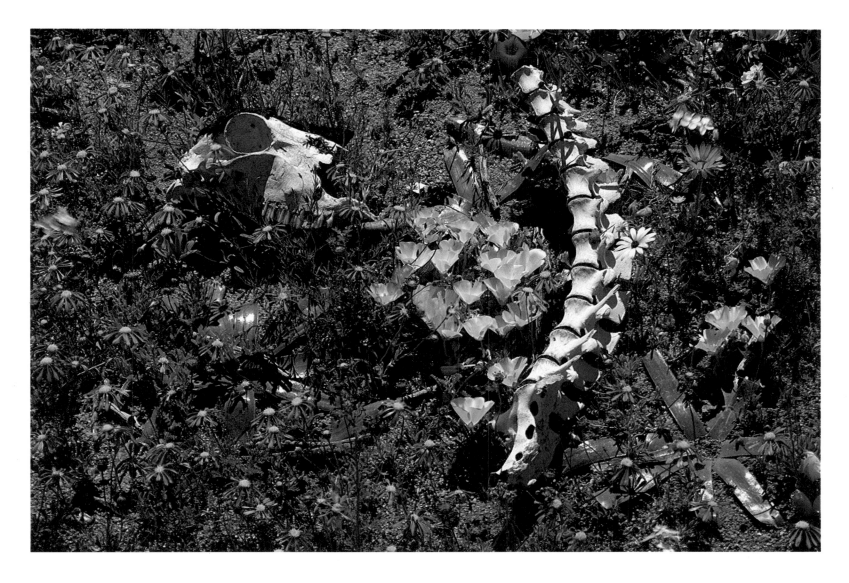

It's possible to spend an entire day around a rock garden like this one near the Anenous Pass, without exhausting the possibilities for seeing and photographing. When you take the time to explore a small area, you become more sensitive to the natural relationships between rocks, flowers, insects, and other natural things, and you learn that nature's visual designs are expressions of these relationships.

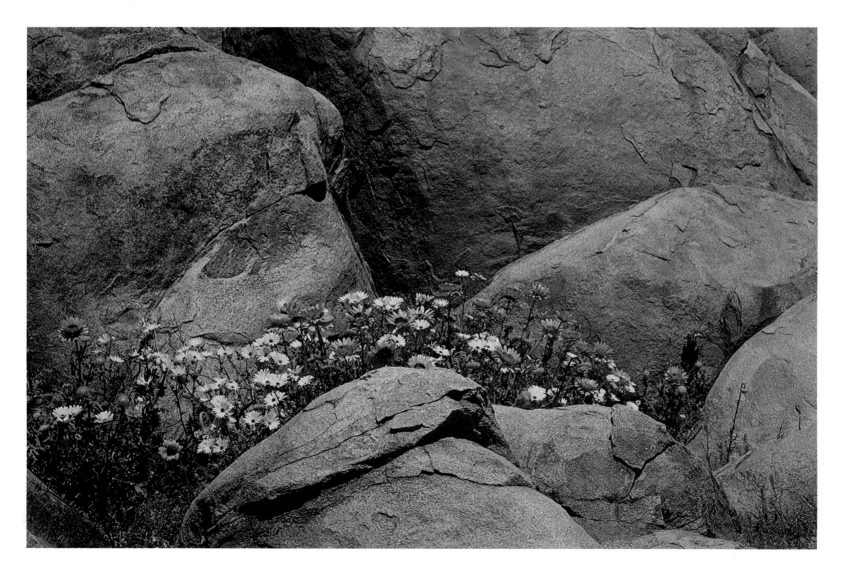

A single blue *Felecia* accents a small group of *Nemesia ligulata.* Although both flowers can be found throughout much of Namaqualand, this particular combination was growing in sandy soil along the roadside near Lutzville.

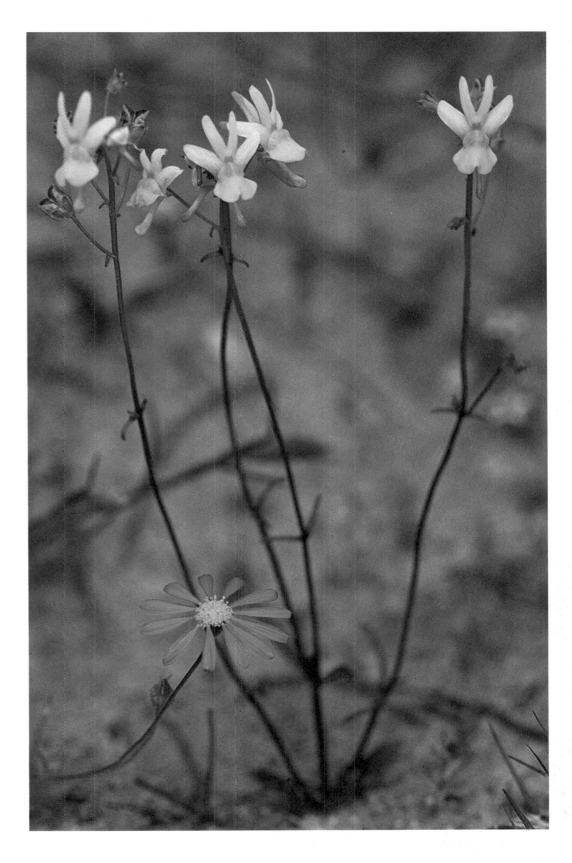

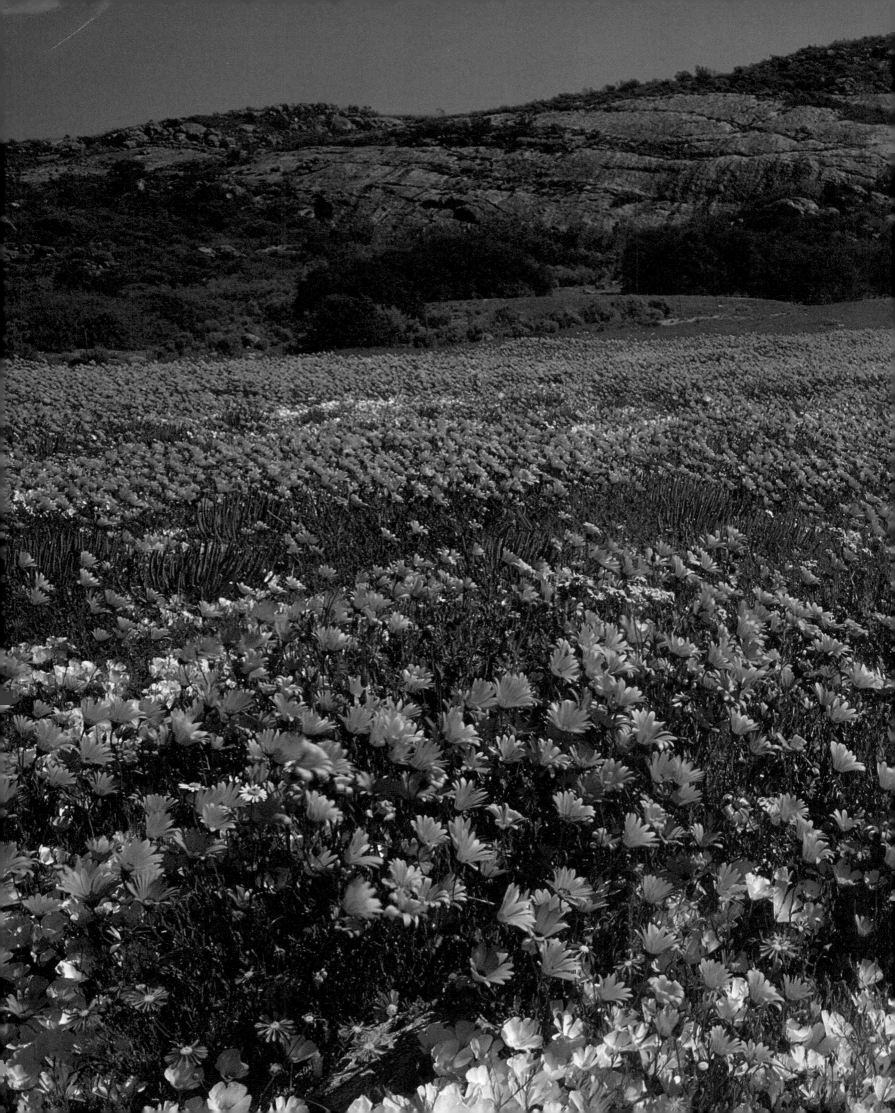

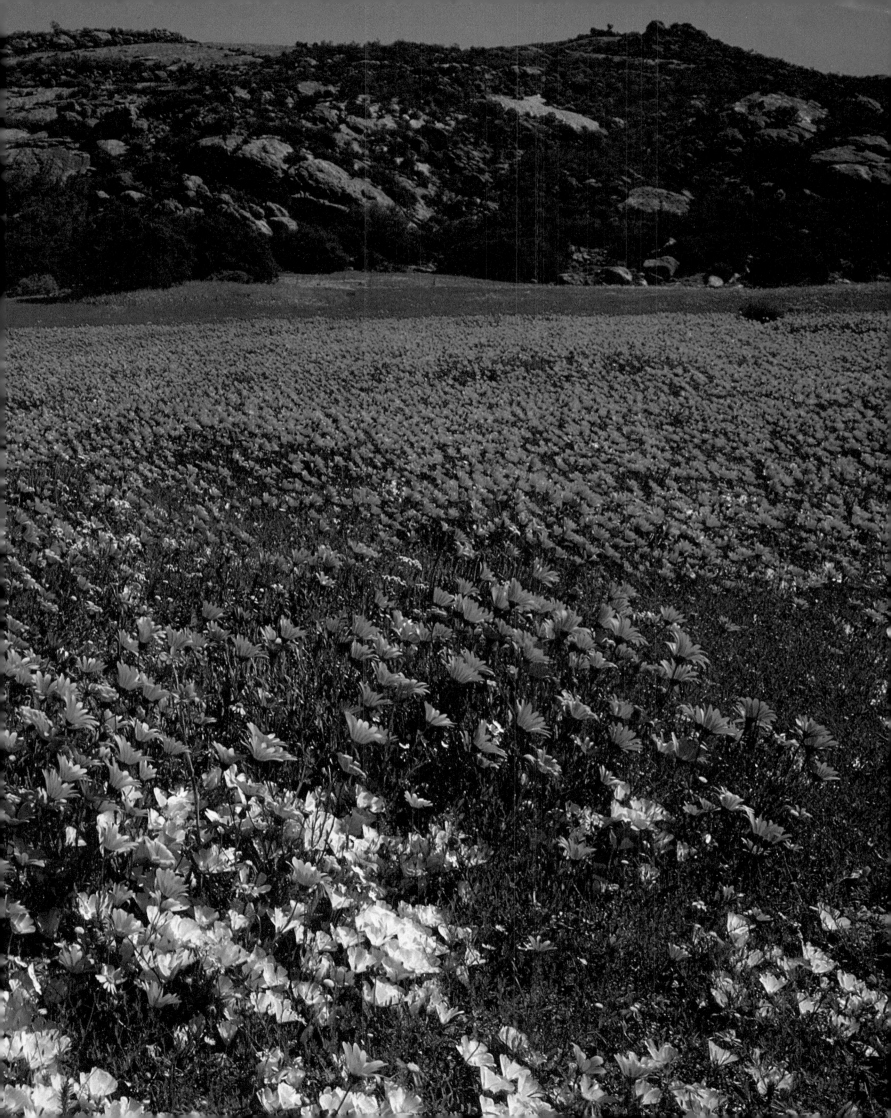

PRECEDING Brilliant afternoon side lighting floods a field of Namaqualand daisies, *Dimorphotheca sinuata*.

BELOW The rocks of the Richtersveld glow in the evening light, often providing a stunning backdrop for the occasional tree or shrub that manages to survive in this harsh environment.

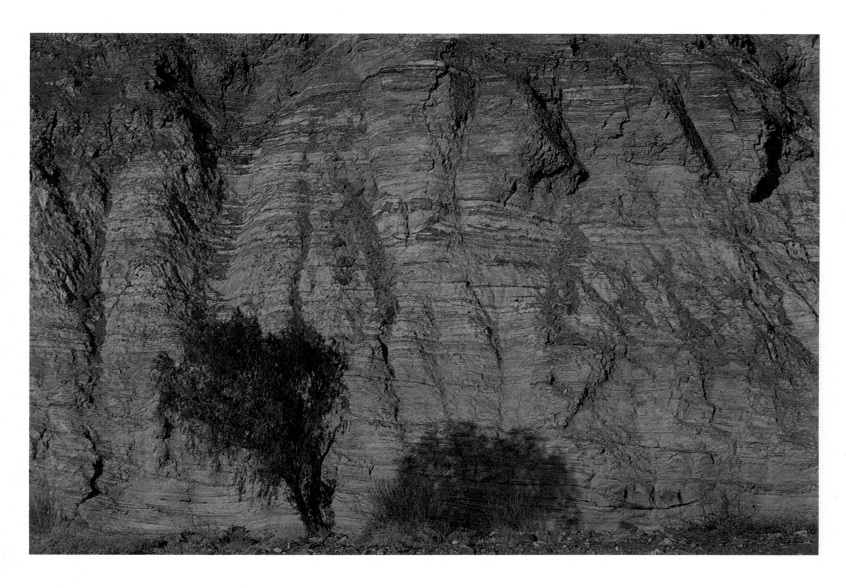

The corms of *Gladioli equitans* and those of its first cousin, *Gladioli alatus*, lie buried in the soil of rocky crevices. Only rarely are conditions ideal enough to produce displays like this. Even then, the beauty of the blooms can only be viewed by hikers and climbers.

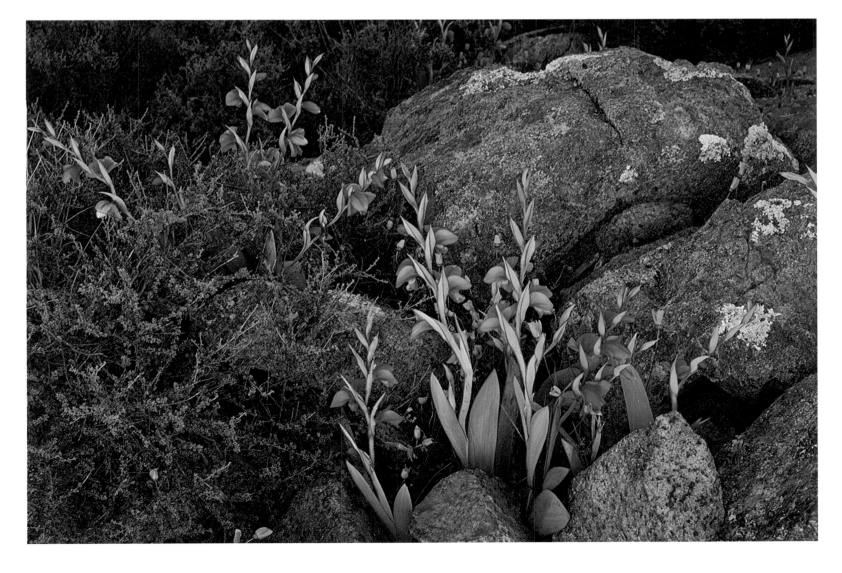

While scorching east winds may suddenly strip the land of its flowers and brutally impose a season of heat, spring may also disappear slowly, flower by flower. There is a certain sadness about this quiet, lingering departure, like watching your children pass the peak of their physical beauty or an aging athlete struggle to repeat past glories. We see in the flowers the stories of our lives.

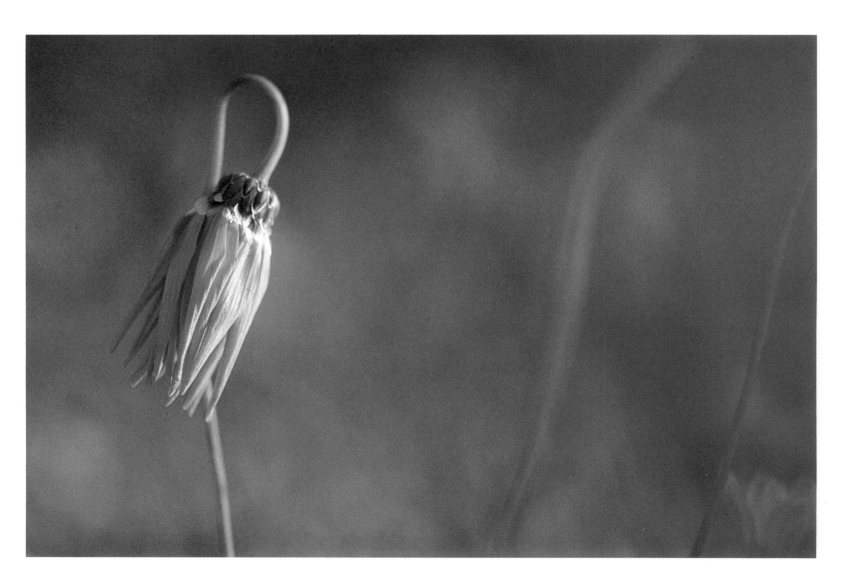

Healthy sheep and healthy flowers are symbols of plenty. Rain has fallen abundantly and, for a while, Namaqualand is a lush garden, not a semi-arid desert. A spring like this is the reward for patience and endurance. Life is good; smiles and laughter are the common punctuation marks of a farmer's conversation.

BELOW Hundreds of tiny gardens can be found on rocky hillsides. These miniature arrangements are just as striking as the vast fields of colour.

OPPOSITE If you are driving through Namaqualand in spring, you can stop your vehicle practically anywhere and discover a variety of plants in flower. This magnificent *Ixia* was growing in a rocky ditch less than a metre from the tar road on which I was travelling, though I noticed it only after I had started to explore the roadside on foot.

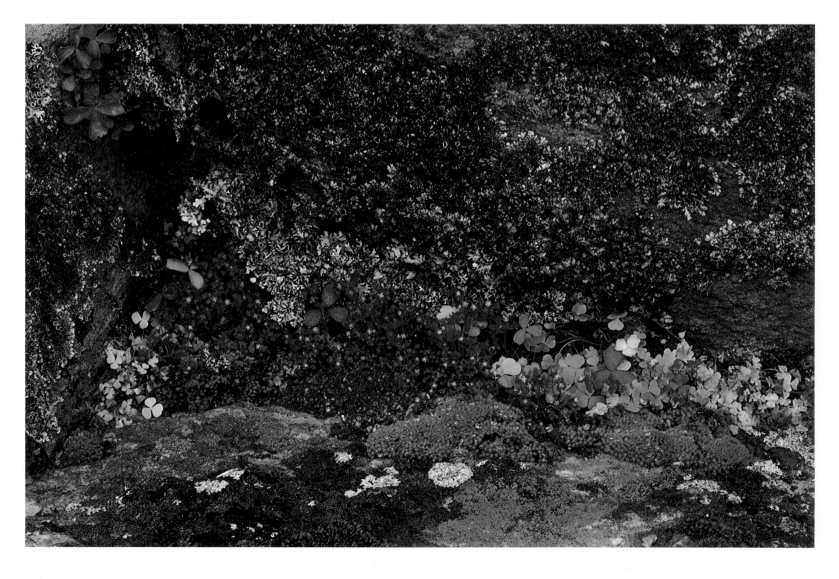

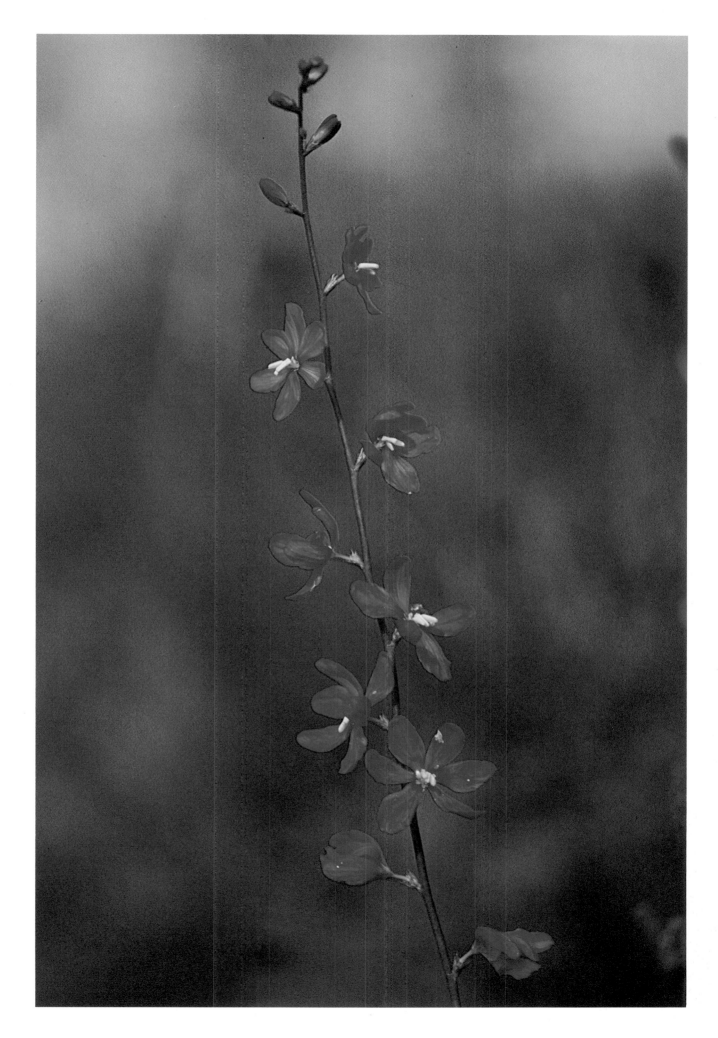

A day in the Kamiesberg

Kamieskroon, September 16

06:10 At the first hint of dawn, I rolled out of bed and peered through the curtains. The sky seemed clear – a lone star still twinkled above the mountains – and the fierce wind of the last two days had abated. I dressed quickly, put a camera on a small, sturdy tripod, loaded it with film, and laid a second camera and extra films on the bed so I wouldn't forget them. Just as I was completing my preparations, there was a knock on my door. Coffee. This morning I would drink it quickly.

06:40 The air was chilly as I crossed the dirt road in front of the hotel, but I didn't mind. Soon I'd be warm enough from hiking. I climbed over the fence into the pasture and headed for the big klipkoppie, which was already rimmed by early light. The sun would rise in about 20 minutes – I wanted to be at the top of the koppie by then. Soon I realized I was climbing so swiftly that I wasn't seeing anything, so I slowed down. Almost immediately I noticed small patches of blue in fissures in the rock – babianas in peak condition. I set up my tripod, put a macro lens on my camera, moved in close on a clump of the flowers, and made a time exposure of two minutes. (The photograph is on page 35.) The patterns of lichens also caught my eye, but I decided to photograph them another time.

As I walked up the long, smooth granite ledges, I passed several deep pools in the rock. The water was perfectly calm, mirroring patterns of rocks and flowers. At that moment, the first warm pink rays of sunlight began to play on peaks to the west. Kamieskroon lay below – the white buildings glowing in the deep shadows. I paused for several moments to photograph the scene – and to enjoy the beauty and the silence.

07:20 Just as the sunlight spread over the village, I reached the top of the koppie. A heavy white mist was quickly drifting over the mountains beyond the village. Soon it enveloped the entire area. To the east the peaks of the Kamiesberg Pass were now swathed in a golden haze. With my zoom lens I was able to frame this scene and to capture this moment. (The photograph is on page 93-108.)

07:50 I began my descent, making my way down a long, sloping ledge to a tiny pool where miniature white water lilies were blooming. Here I stopped to make several compositions with both macro and zoom lenses. (One of the photographs is on page 38.)

I was hungry now, and breakfast would be waiting, so I moved quickly down the last granite slope, startling a rock rabbit as I passed near a big boulder. In my haste I got myself completely entangled in the pasture fence. After carefully freeing myself from the strands of wire, I made a final dash across the road, and into the hotel just in time for breakfast – mealies, sausages and eggs, toast and jam, and coffee. A most welcome meal!

08:45 Coenie and Colla, my good friends the hotel owners, joined me for coffee. Within a short time we had settled our plans for the day – Colla and I would head for the Kamiesberg Pass where the flowers should be at their peak.

Colla loaded the Datsun bakkie with enough food to last us for a week – three kinds of sandwiches, cold mutton, cheese, oranges, pears, apples, guava juice, buttermilk, a thermos of hot water for tea, and a bag of sweets. Then Coenie gave us some antelope biltong to chew on – in case we might get hungry.

By now it was 15°C, and though we realized the temperature might reach 25°C, we tossed in warm sweaters in case a cold wind should come up. I placed our photo equipment on foam pads because the road would be rough, then checked for the wildflower guidebook, which I found safely packed with the mutton.

09:30 We set off in high spirits. Colla watched for wildflowers; I watched for ruts and bumps in a road that twisted and turned almost at whim. It was wet and muddy at first, with water flowing over it in several places. We stopped at a rock face lined with magenta lapeirousia – the most beautiful I'd seen – and photographed them from many viewpoints, both very close up and farther away to include their rocky habitat.

10:15 We travelled through the pass and out onto the plateau to the first farm. The flowers here had become more colourful each day and now they were spectacular. With a wave to the farmer, Colla headed left and I went right, agreeing to meet at the bakkie for tea in an hour.

On the far side of the field, I was surrounded by orange daisies, white sporrie, and a few blue felicias. I set up my tripod in the field of flowers, put a wide-angle lens on my camera, and made several shots of the floral carpet – with no definite centre of interest. Then I moved a little to the left where a line of green grass curved through the yellow, and carefully composed and recomposed. But I still wasn't getting the effect I wanted. So, I lowered the tripod to half a metre from the ground, positioned the camera vertically, moved in close on the foregound daisies, and tilted the camera up a fraction to include a sliver of sky. This was what I wanted – a long sweep of flowers to the horizon. Namaqualand in spring! (The photograph is on page 19.)

I switched to my 85-200mm zoom lens and lowered the tripod almost to ground level. I extended the zoom to maximum length, set my camera at the minimum focusing distance and the shallowest depth of field, and chose an appropriate shutter speed. Then I started moving the tripod slowly forward, poking my lens into the flowers so they brushed against the lens, and through the viewfinder watched the flowers move in and out of focus. I became lost in a world of orange, white, and blue flowers, occasionally shooting when two or three daisies would come into focus and make a pleasing composition.

Without moving the tripod, I refocused on a spot of blue felicias, and was able to photograph bees and other insects coming for nectar and pollinating the blossoms. (One of the photographs is on page 26.) A few minutes later, the bees started landing on me – attracted by the nectar and pollen that were by then all over my clothes.

I left my spot of the past hour, and picked my way through an expanse of white sporrie mixed with orange and yellow daisies, always being careful not to walk through a pattern of flowers I might want to photograph. The sun was warm, the breeze was gentle, flowers rolled like clouds in every direction, and I began to lose sense of time, and of myself. Eventually the desire for a cup of tea brought me back to reality. I started slowly in the direction of the bakkie, though

I couldn't resist stopping several times for more photographs – for those floral designs and moments in time that would never again be witnessed.

11:45 When I finally arrived back at the bakkie, Colla was nowhere to be seen. I set about brewing tea, and was just pouring myself a cup when she arrived breathless with news of a rare discovery – a flower that she hadn't seen in years. She had spent an hour crawling around it, photographing it from every conceivable angle. The rest of the time she had spent sitting among the daisies, sharing with them the sun and the breeze. Between sips of tea she rubbed lotion on her face, and declared that I badly needed some too. Tea became an early lunch of biltong, a sandwich, and fruit.

12:30 We jumped into the bakkie and headed for an abandoned farm two kilometres away where, according to a report of a passing school boy, the flowers were even better. However, we had travelled only 300 metres when a spectacular klipkoppie came into view. There were ursinias by the thousands, rosy lapeirousias by the millions, button flowers, lachenalias, and a host of other flowers that were impossible to pass by. I grabbed my camera and raced up the koppie into the flowers. A sudden movement stopped me in my tracks. I scanned the rocks. Then I spotted it – a huge puff adder sunning itself in a secluded ring of rocks. It had its eye trained on me. Could I go closer? I advanced the film and cocked the shutter – and made one cautious step forward. The snake raised its head in warning – I pressed the shutter release, and retraced my steps back down the koppie.

Colla and I went to other parts of the koppie, and never saw another snake on this or on any other trip. Soon, Colla was flat on the ground using her close-up equipment to shoot lachenalias against the deep blue sky. I wandered around with my zoom lens framing small rock gardens that dotted the koppie. (See the photograph on page 48.)

After an hour, Colla shouted from a rock ledge below me. She had unpacked the fresh buttermilk from her sister's farm. We sat on the rocks and traded discoveries while quenching our thirst. Finally, we had to decide whether to stay here or to press on. Some cold mutton helped us to resolve our dilemma – and off we went.

14:45 Colla opened and closed farm gates as we drove, and we gained half a kilometre before coming to another stop – this time beside a heap of boulders crowned with brilliant red lichens.

15:15 Back in the bakkie again. We managed another 100 metres before again giving in to the flowers. We sat for a moment bemoaning our lack of progress, then remembered our goal was to photograph and to enjoy ourselves, and that we surely had accomplished. Soon both of us were again on our hands and knees making close-ups of brick-red gazanias, oxalis, and several species of the iris family.

From time to time we checked our identification of an unfamiliar plant with the wildflower guidebook and, when we were uncertain about a species, we would try to find and examine another specimen. Because different plants often had the same common name, we made a point of learning their botanical names. We also examined the leaves, stems, and flower parts to see how various plants adapt to the demands of their environment.

Gradually we drifted away from each other. I became fascinated with a termite

hill, and wondered if there was a way I could show with pictures the importance of termites in churning the soil to allow moisture into the dry earth surrounding their rock-like hill. I decided the flowers that formed a collar around the hill were sure evidence of this important natural process, and set out to include them in my photographs of the termite hill.

Colla returned for more film and lured me to her spot with the discovery of a white duikerwortelblom – the first she had ever seen in her lifetime in Namaqualand.

A car stopped by our bakkie, the only vehicle to come our way all day. We quickly introduced ourselves – they were a local farm family, and were interested in my feelings about the flowers. We shared sandwiches and oranges and stories. They told us that the flowers were even more splendid at the abandoned farm we had set out to visit hours ago.

The sun was dipping lower in the sky, and I could see a few sporrie starting to close a little. We became anxious to be on our way, waved our good-byes, and set out for the abandoned farm vowing to look neither left nor right until we arrived there.

16:30 There it was. A valley of flowers beyond anything I could have imagined. This old farm, set in the valley between long, converging rocky hills, was the stuff of dreams. When I stood on a koppie I could see bands of colour stretching to the horizon – purple, orange, white. My feet were buried in intricate colour tapestries. The profusion of colours was overwhelming. We wasted no time in beginning to photograph, but soon realized that we would need to spend an entire day here, or even two. Tomorrow, for sure. (And tomorrow it was. Some of the photographs I made are on pages 20-21, 60-61, and 96.)

17:30 Reluctant to leave, Colla and I finally headed back across the fields to the mountain road. By now there were long shadows on the veld and every koppie seemed dramatically etched with back-lighted patterns of golden ursinias. We stopped many times to photograph or simply to walk through the flowers and the fields.

Before long we were starting down the pass toward Kamieskroon. The entire mountainside was bathed in bronze, and here and there small streams of golden water fanned out across smooth rock faces. Even in the bakkie, we could sense a stillness creeping over the land.

18:40 Colla and I stopped—for the last time—at the foot of the pass. By now the huge, dome-like rocks on the mountainside were glowing a deep pink. We made our last few pictures of the flowers in their rocky settings. Then, we climbed a great curving outcrop of rock, and sat for a while to watch the sun set behind Kamieskroon and the mountains to the west.

In the twilight we returned to the bakkie for a final cup of tea. As we sat by the roadside, the first frogs began to sing. The end of our day was the beginning of activity for all those living things that survive in this land by avoiding the heat of the sun.

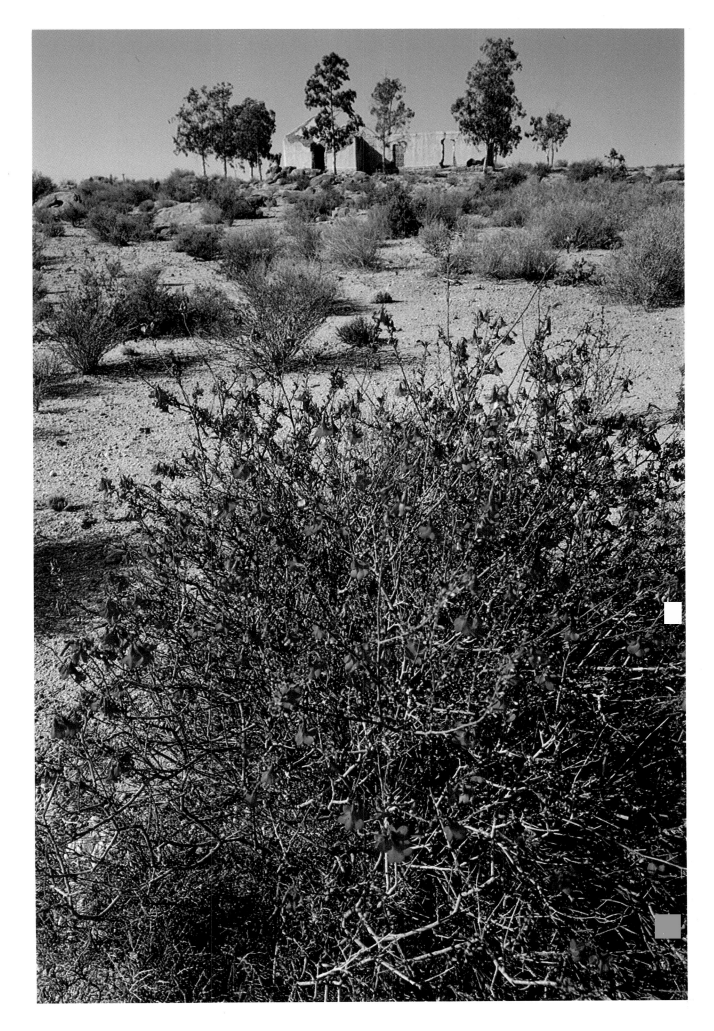

PRECEDING At the northeastern boundary of Namaqualand, between Pofadder and Aggeneys, blossoms of the desert rose, *Hermannia*, relieve the bleak desert landscape. After months of drought, the fuchsia-like flowers are a welcome sight in this barren land. In the distance, the crumbling remains of an old farm home are evidence of broken dreams.

BELOW Of all Namaqualand's flowers, none reflects the sun's rays more brightly than *Grielum humifusum*. Its luminescent cups, following the sun as it arcs across the sky, resemble miniature satellite receiving dishes turning slowly to capture signals from space.

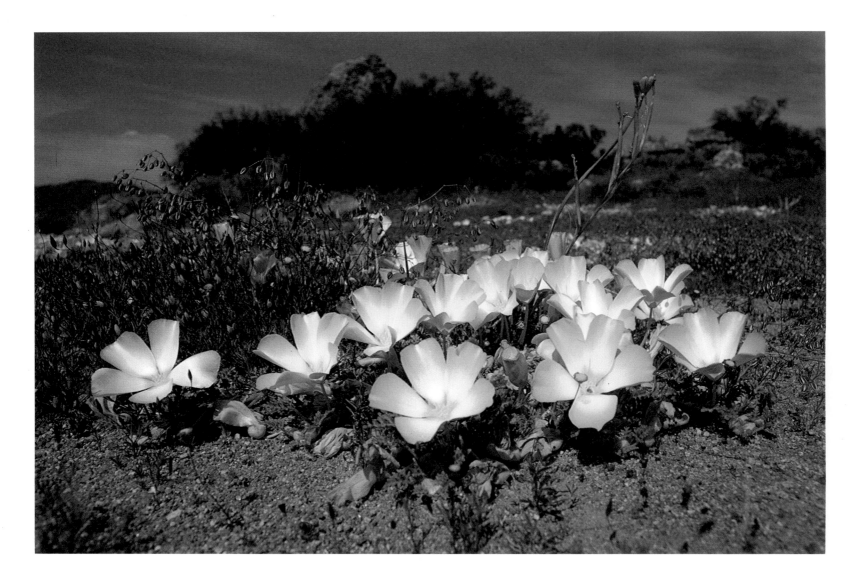

Perhaps no other succulent is as familiar to the people of Namaqualand as *Herrea.* The genus has several nearly identical species, and most people can't tell them apart. Each plant forms a large circular clump on sandy soil, and carries many huge flowers at a time. A field of *Herrea* is a dazzling sight, but close up the silvery-yellow blossoms are even more striking. The long, thin petals surround masses of stamens, which are invaded by tiny black midges and flies that pollinate the flowers.

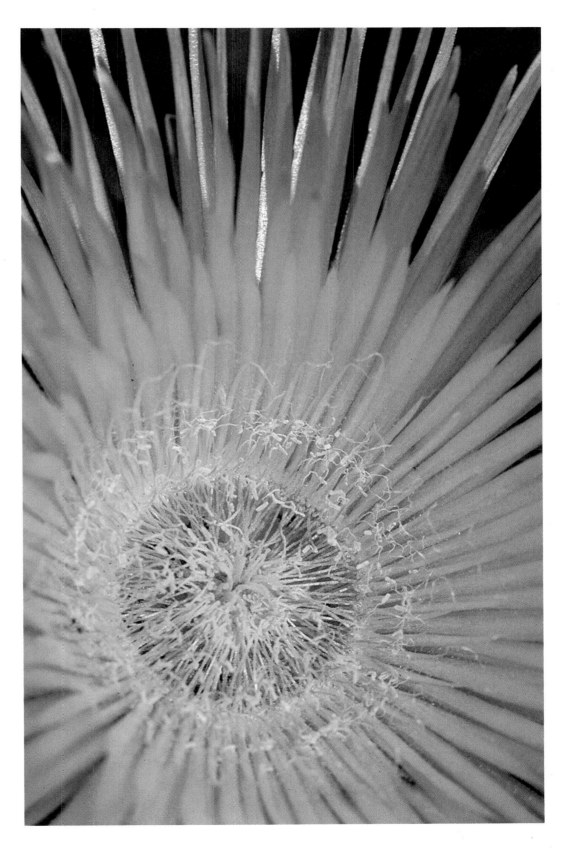

The many species of the mesembryanthemum family put on striking displays all over Namaqualand – both as individual plants and in masses. A spring traveller on the main highway is likely to see a superb display on the hills around Garies, where these were photographed. The blossoms of these and other cerise flowers take on a redder hue in bright sun, and a bluer cast when shaded by a passing cloud.

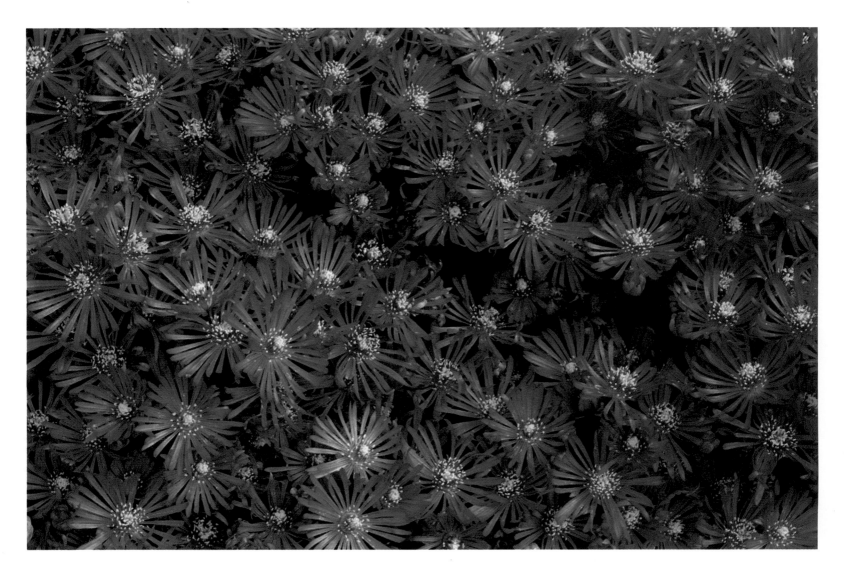

The giant sour fig, *Carpobrotus quadrifidus*, is a mesembryanthemum that grows mainly in sandy coastal areas of Namaqualand. Its immense cerise flowers, with a white band ringing the stamens, dazzle the eye. This perennial succulent has thick, triangular leaves that trail over the ground on long stems.

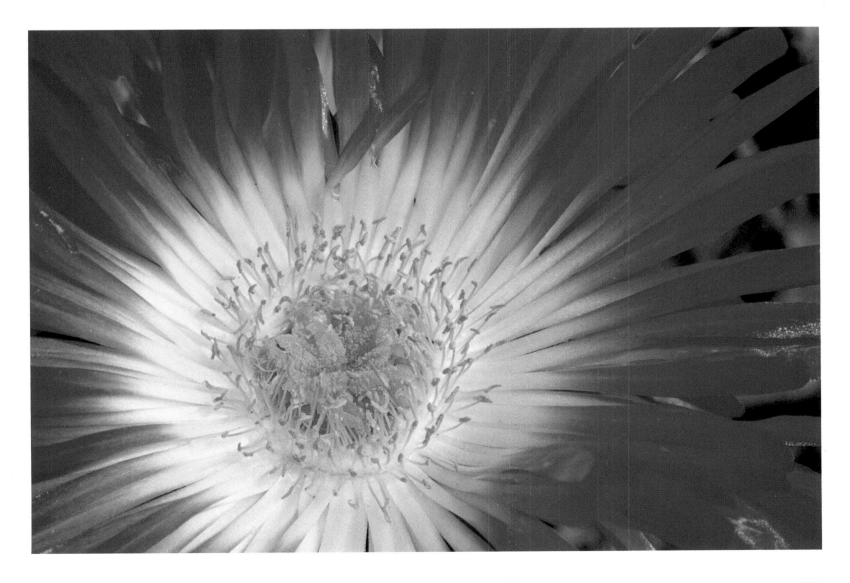

Conicosia pugioniformis is a yellow mesembryanthemum at the southern extreme of Namaqualand. Scattering across red sand near Vredendal, its warm hue leads the eye to the horizon. Here and there white daisies share the same surroundings.

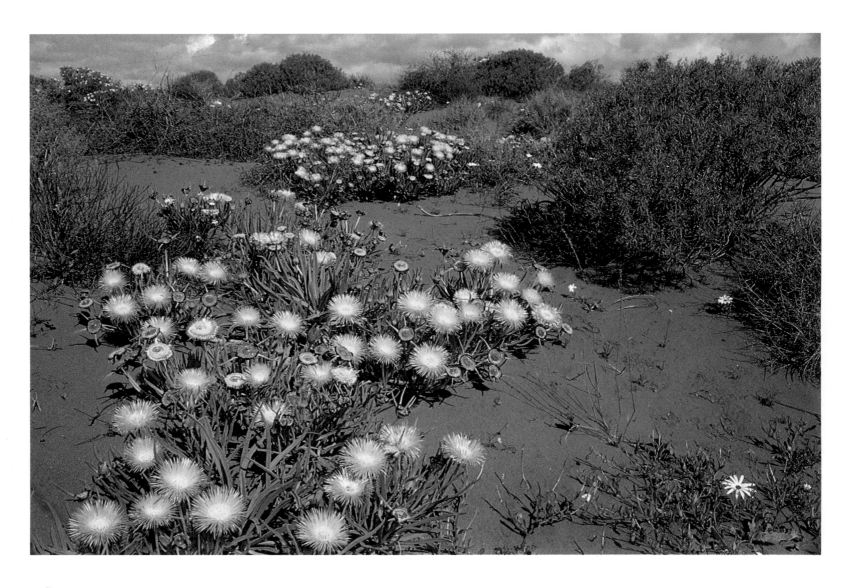

BELOW Red sand is more than a brilliant background for the glistening white petals of *Dimorphotheca pluvialis*; it also reveals the usual natural environment of the species. The colours of natural things – of the soil, the flowers, the birds, the insects – are important clues to the various roles they play in nature, and nowhere is this more true than in Namaqualand.

OVERLEAF Masses of pink mesembryanthemum, *Lampranthus*, catch the last rays of sunlight along the road to Port Nolloth, just west of Steinkopf.

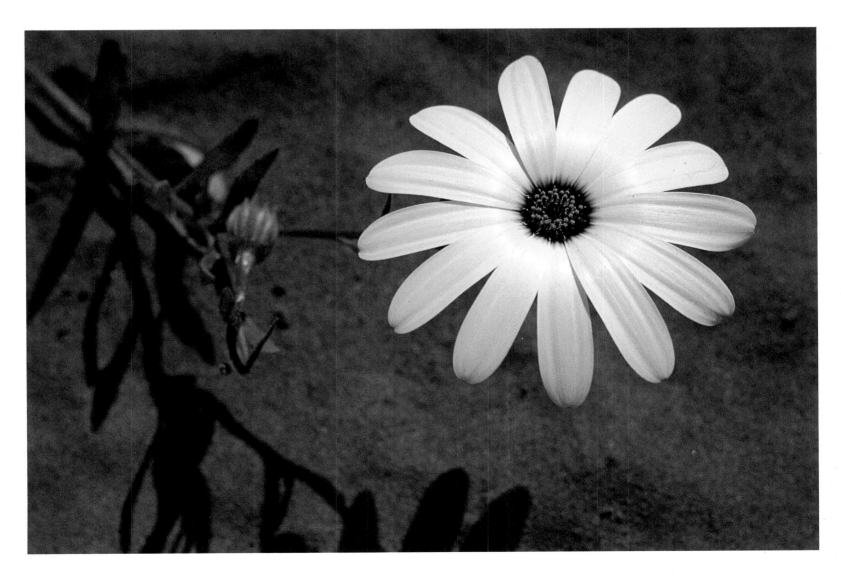

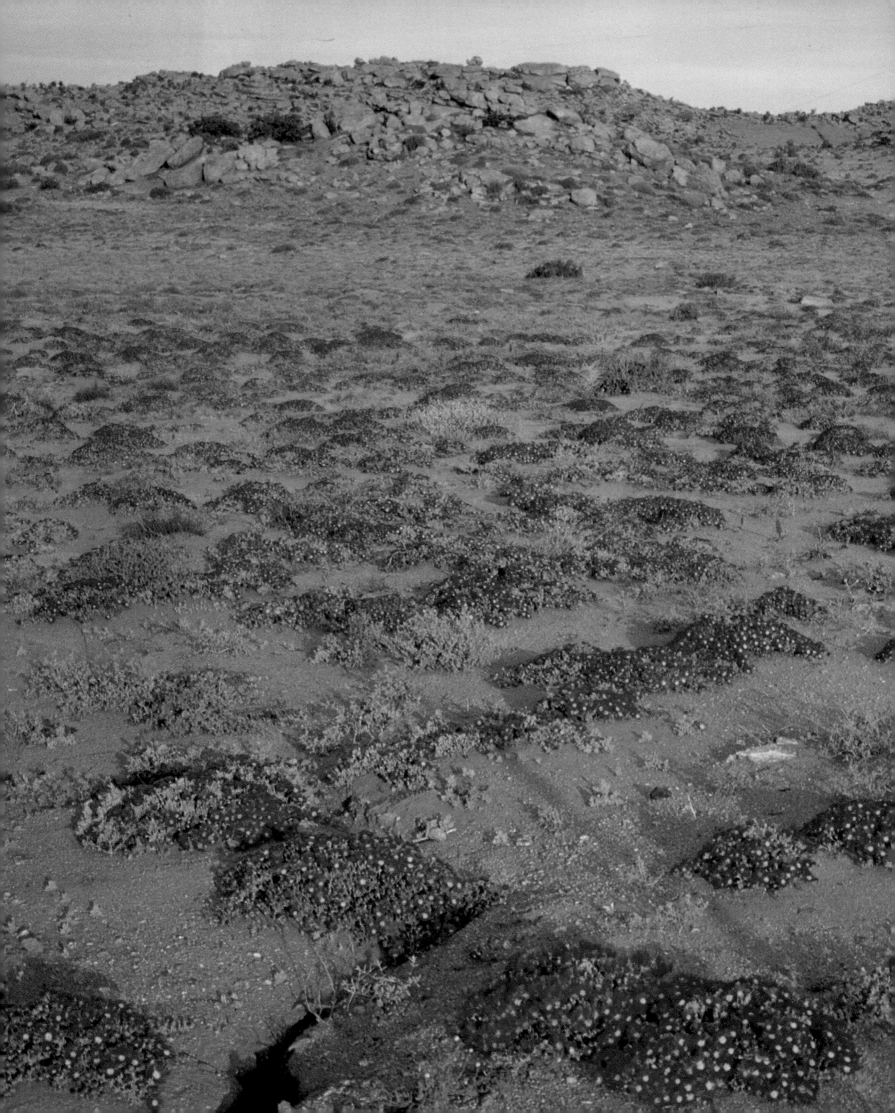

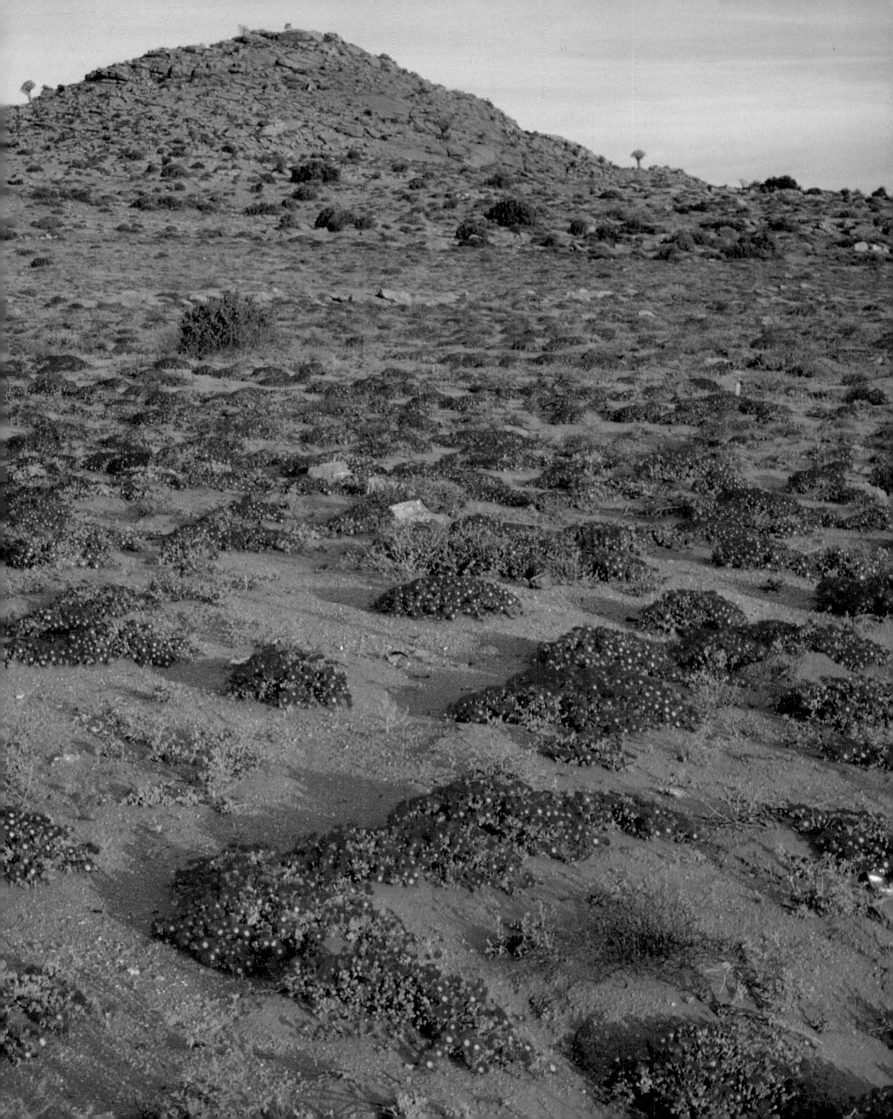

Just east of Aggeneys, *Gazania lichtensteinii* emerges from cracked clay. After a heavy shower, water lay in this shallow depression for only a few hours before evaporating in the burning sun. But, the moisture was sufficient to stimulate growth and encourage bloom.

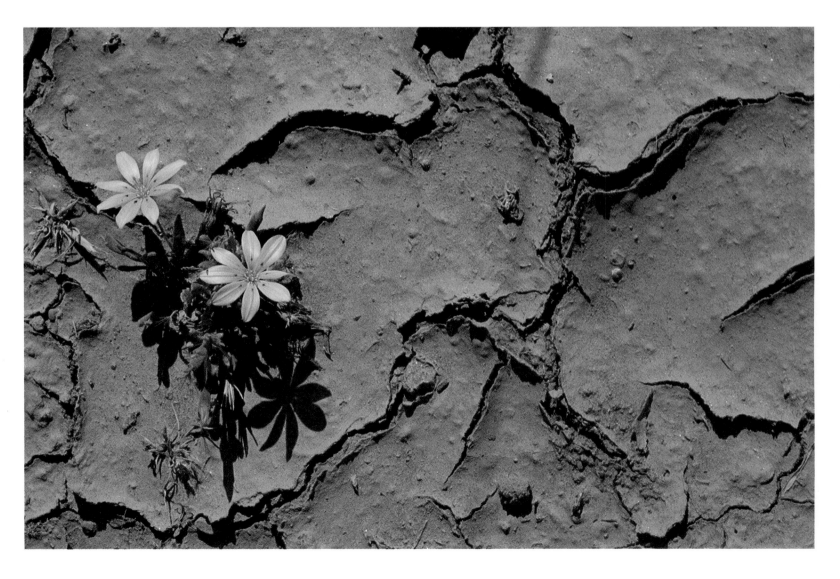

This *Ornithoglossum* is a lily that grows throughout Namaqualand. Its greenish blossoms, with purplish-brown margins and flaring petals, are subtle reminders of the range of hues found among the flowers.

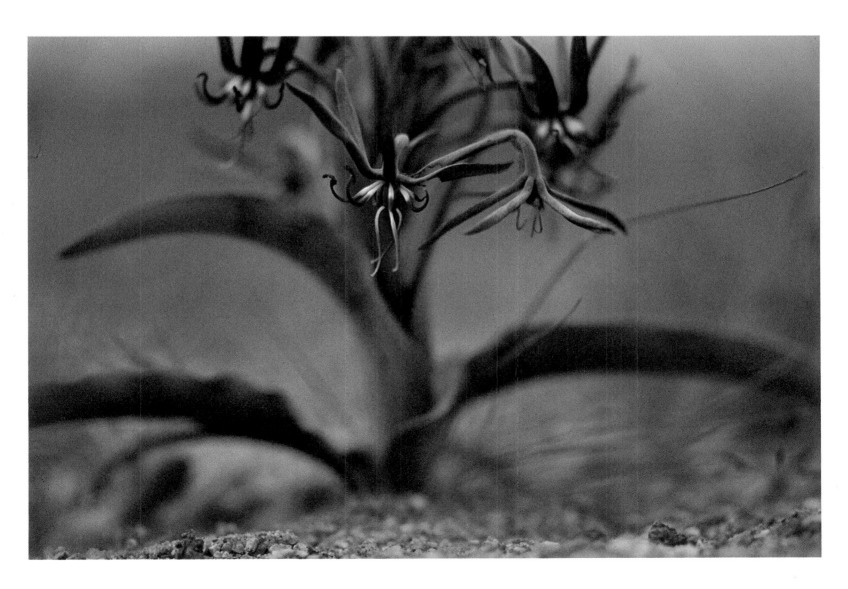

Pelargoniums belong to the geranium family, and are called geraniums over much of the world. Approximately 250 species of this genus grow wild in southern Africa, many of them serving as parents for the modern garden hybrids and house plants. No Namaqualand geranium is more striking than *Pelargonium incrassatum;* its glowing cerise blossoms are visual accents in many natural rock gardens and fields. This plant was growing along the main highway between Garies and Kharkams.

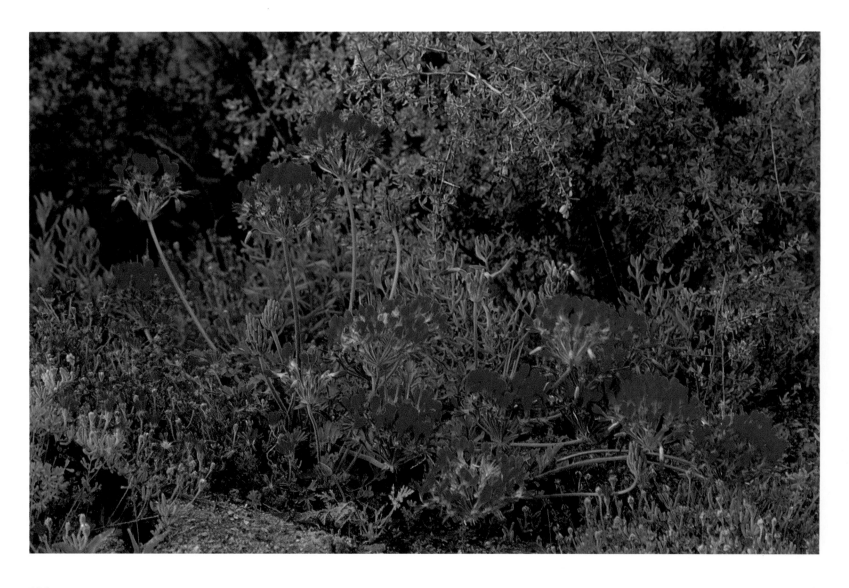

The perky blooms of *Diascia longicornis* can elicit a chuckle. Perhaps it's the twin spurs that flare out like horns from the back of each blossom, or perhaps it's simply their cheerful, open faces. Whatever the reason, *Diascia* get on well with other plants, and can be found growing among sporries, *Ursinia*, *Osteospermum*, yellow mesembryanthemum, and a host of other species. It can become particularly gregarious in moist, sandy soil.

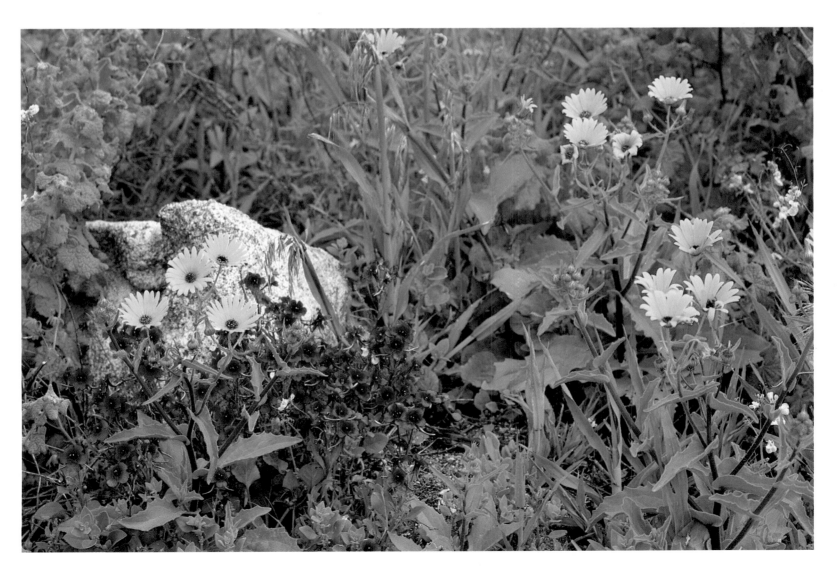

Normally, the two leaves of *Whiteheadia bifolia* lie opposite each other on flat, sandy earth in the shade of rocks. However, this specimen selected an unusual niche – a high crevice under a large overhanging ledge – and grew its leaves in a way that they could catch light. Although the plant was permanently in the shadow of the rock, for several hours a day brilliant sunshine reflected off a nearby waterfall onto the ceiling and back wall of the ledge. Rooted in the droppings of rock rabbits, this remarkable lily had enough light to produce a healthy spike of flowers.

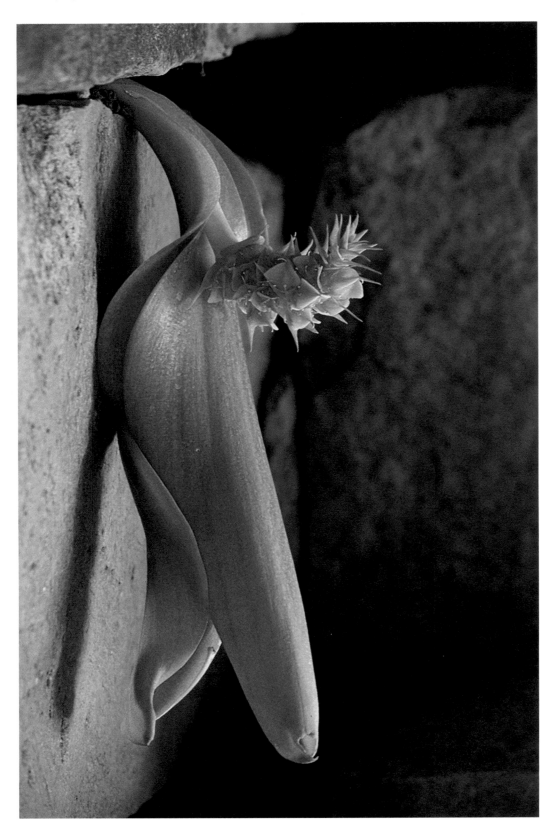

Carved by water over millions of years, a natural arch stands like a gateway to a waterfall near Kamieskroon. Only a hiker would find this spot. There is no road, no trail. Sitting beside this splendid formation as the rising sun warms the stone, a hiker might hope deeply that it will be preserved forever as a place of solitude and peace.

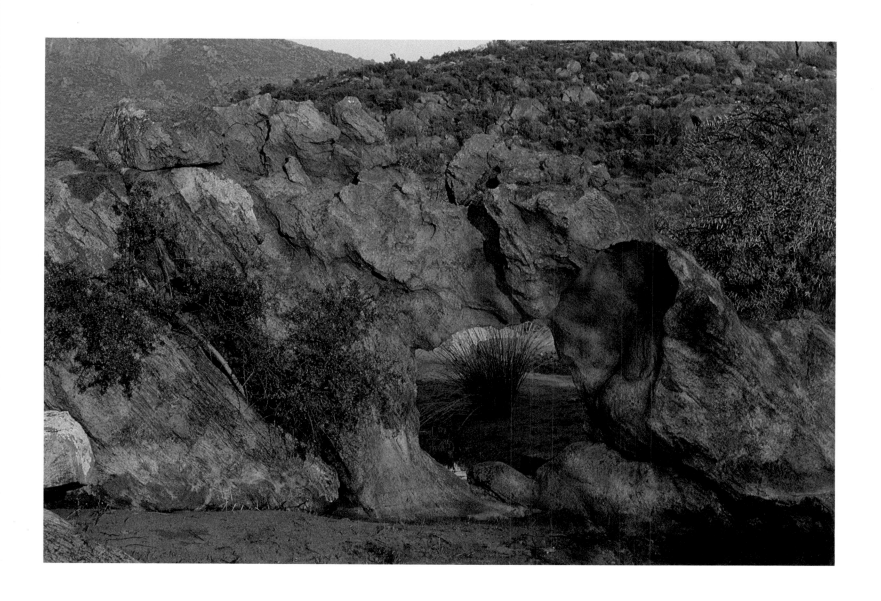

Long shadows fall across barren sand. Flowers that protect the soil
from searing heat and driving winds are gone. Spring is over.

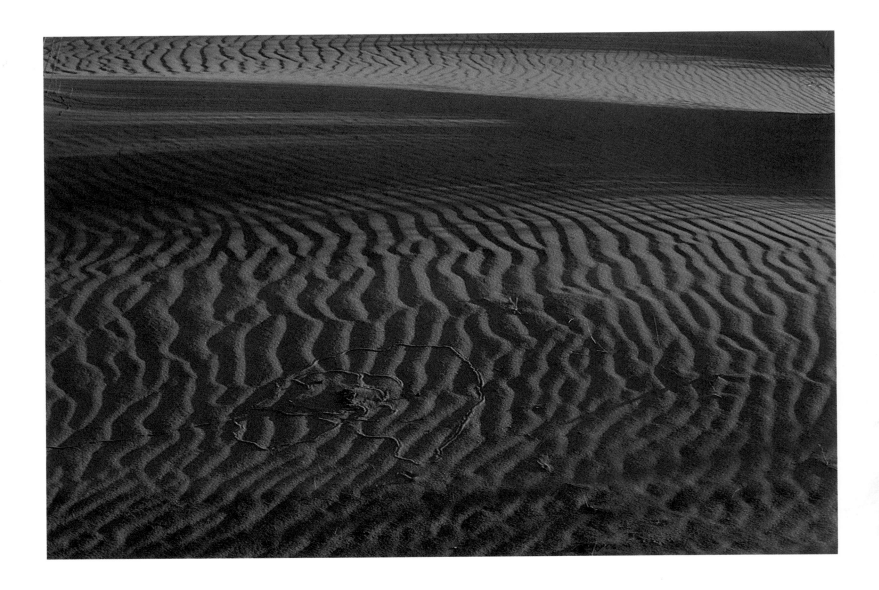